RICHARD SCHMID PAINTS LANDSCAPES

RICHARD SCHMID PAINTS LANDSCAPES

BY RICHARD SCHMID

Watson-Guptill Publications/New York

Pitman Publishing/London

First published 1975 in the United States and Canada by Watson-Guptill Publications,
a division of Billboard Publications, Inc.,
One Astor Plaza, New York, N.Y. 10036

Library of Congress Cataloging in Publication Data
Schmid, Richard, 1934–
 Richard Schmid paints landscapes.
 Bibliography: p.
 Includes index.
 1. Landscape painting—Technique. I. Title.
ND1342.S35 751.4′5 74-20955
ISBN 0-8230-4862-4

Published in Great Britain by Sir Isaac Pitman & Sons Ltd.,
39 Parker Street, London WC2B 5PB
ISBN 0-273-00900-1

Manufactured in U.S.A.

First Printing, 1975
Second Printing, 1976

For Hans

Contents

*I would like to express
my gratitude to
Willi Aust and Joseph Seewald
for their special help
during the time this book
was in preparation.*

RICHARD
SCHMID
PAINTS
LANDSCAPES

Introduction

I was 14 years old when I did my first landscape painting and I have been hooked on it ever since. Somehow, back in those halcyon days, I managed to work my way into a group of middle-aged Sunday painters headed by an energetic Italian named Gianni. Each Sunday morning that summer and fall of 1948, I boarded a bus and headed for our rendezvous—an obscure bar called Happy Wanda's on the outskirts of Chicago. From there we ventured forth in search of Nature and Beauty and invariably ended up painting in one of the cornfields near the Des Plaines River. After getting us started properly, the genial Gianni would run among us like a diligent sheepdog, criticizing here and demonstrating there. He ran himself ragged and genuinely earned the two dollars he charged. I am forever indebted to him for bringing me to the first of many confrontations with the "moment of truth," especially at my tender age. To begin with, he taught me how to paint with *paint*, rather than with a brush. One day, for example, he scooped up nearly a quarter-pound of white paint (with a touch of yellow), slapped it on my canvas, and painted an entire sky in one stroke—all without saying a word. His demonstration was far more eloquent than words could have been. Another Sunday, he demonstrated that things are not necessarily the colors we call them—the grass is not green, the sky is not blue, clouds are not white. It was an unforgettable yet often painful experience. He did not teach me all I know about landscape painting, but he certainly shoved me in the right direction at the right time. Most importantly, he taught me to *see*—which is what this book is all about.

This is not a book on how to paint "landscapes" in the usual sense. To me, landscape is nearly everything under the sun—not just the usual range of rural subjects or nature studies associated with landscape painting. A metropolitan street, for example, is a landscape just as surely as the Illinois cornfields.

Landscape painting is not just another subject matter, either. Like figure painting or still life, it is an art form in itself, and the subject within the landscape is often (and ideally) secondary to the main idea of *seeing*. The apparent subject is little more than a vehicle or excuse to reveal a more subtle but powerful insight. Of course, this is hardly a new idea. It is self-evident that art is a language, and like any other language, its purpose lies within the content of the expression. The subject, however interesting in itself, cannot stand alone for long. When a painter understands this, he becomes an artist.

I have my own set of standards for painting, some of which apply to landscape painting in particular. First of all, whatever I paint must arise from my personal experience. There can be no compromise about this because it is fundamental to the concept of painting as a language. My painting will conspicuously lack conviction unless I go to a place and see or feel something about it that compels me to paint.

Another personal standard is that the end result, the finished painting or sketch, must be plausible. That is to say, it must be convincing in the sense that it does not appear as if nature sat up and posed for its portrait. Just as in figure painting, the impression must be conveyed that the subject is unaware of being observed. The paradox here is that in order to accomplish this, the subject must be observed with intense scrutiny. Plausibility, in the realistic painting I do, necessarily assumes technical proficiency and an eye for the smallest mistake that could ruin the credibility of an otherwise well-painted landscape.

I must reiterate here that I am only speaking of my own work. Many artists have done fine paintings from vantage points that are impossible without mechanical or optical aids, such as aerial views, underwater scenes, and head-on cattle stampedes. This is fine, but not for me. While I do use aids (mostly just a camera), my paintings have vantage points and perspective levels that are ordinary and plausible. For example, the horizon line or vanishing point in my work is invariably the same that any person of my height would experience (with their feet on the ground).

Finally, plausibility also includes avoiding the "picturesque." I have been as guilty of painting pretty pictures as any other painter. Probably, it is necessary just to get it out of one's system, and the sooner the better. I think I am wiser now—not so wise that I can avoid the familiar clichés entirely, but at least I know when I am within the mistake. A familiar fact of art history is that the landscape as an object of beauty is a fairly recent concept in Western art. The majestic scenery we accept as intrinsically beautiful went largely unnoticed until sometime around the pre-Renaissance artists began to call attention to the paradise we live upon. Until then, a splendid mountain range was probably regarded as a huge nuisance by those obliged to cross it, and as an enormous and mysterious pile of rocks by everyone else. Painters began to reveal the grandeur not only in the extraordinary features of nature, but also in the less conspicuous and commonplace areas of the community.

There is now serious concern about our environment and what is happening to it as a result of human interference. To most serious artists, particularly landscape painters, this concern is nothing new. I think most of us have instinctively known that a deep reverence for life is essential for survival. It is felt by some that the prime function of art is to enhance this concept, which may or may not be true. I feel that landscape painting, like mountain climbing or chess, does indeed have an urgent purpose, but the purpose or function cannot be clearly defined, even in such well-meaning phrases as "the enhancement of a reverence for life." I know serious artists who paint simply for the fun of it. The function or purpose of painting, whatever it is, can only be expressed through the language of painting itself.

In my art school days, I engaged in the normal speculations on this question of the nature and purpose of art. It was invigorating and necessary. Nothing was ever resolved, but out of the endless discussions, a dialogue about painting was created. It is still going on stronger than ever, even though now it is more or less internalized. It emerges from time to time through my work—mostly in my landscape painting. Underneath the physical exertion and concentration of outdoor painting, there is a fascination and tranquility brought about by nature. This experience comes, quietly, as close to happiness as anything I know of. Landscape painters, like bird watchers and bassoon players, live in a world apart—a world that cannot be experienced from the outside looking in.

Richard Schmid
Sherman, Connecticut

Materials and Tools

There are vast differences between studio painting and outdoor work. Although outdoor painting is generally more difficult, there are many traditional ways to minimize the difficulties. For example, extensive preliminary studies, photographic aids, and the extension of painting time over days or weeks (returning when the light is right), are all sound procedures. Occasionally I use these methods, but in general, I find them too cumbersome. In almost every case when I work outside the studio, I use one or more variations of *alla prima* techniques—the completion of a painting in one working session. All my outdoor equipment, materials, and techniques are intended to make this task simple and rapid.

Basically, I use the same materials and techniques in all my work regardless of subject matter. The main difference in my outdoor gear is that I carry only what is absolutely necessary. There is no point in arriving at a painting spot exhausted from carrying around unnecessary equipment.

The painting materials and technical procedures I am going to describe are fundamentally the same as those covered in my first book, *Richard Schmid Paints the Figure*. Five centuries of experimentation and practice have firmly established oil painting as a most useful and versatile medium; even after all that time, oil paint still affords enormous potential for fresh and exciting exploration. I never cease to be fascinated by the variety of effects that oils provide, possibly more than I'll ever get around to testing.

However, innovative ways of employing painting materials are much less important than original ways of seeing your subject and closely relating your visual concept to your finished work. This emphasis on *seeing* liberates the artist from technical inhibitions and permits him to work instinctively, rather than squander his time on exotic tools and techniques.

Grounds

Since I believe strongly in simplifying the technical aspects of painting, I prepare all my own canvases and panels. At a fraction of the cost of commercially prepared products, I can provide surfaces that meet my requirements as to strength, absorbency, permanence, and the wide variety of surface textures I want for various painting contingencies. I prepare canvases the exact size that they are to be used. Once a canvas is on its stretcher, I seldom find the need to remove or restretch it. A hot liquid size of rabbitskin glue equalizes the surface tension of the fabric and renders the canvas permanently and uniformly taut when dry. This also eliminates the powerful uneven pressure that might twist or misalign the stretchers.

I use two high-grade Belgian linens: Utrecht #21A for paintings larger than 16″ x 20″ (406mm x 508mm), and Utrecht #66J for the smaller sizes. First, I cut the unprimed canvas to the proper dimensions and mount it on standard stretchers, tightly enough to eliminate wrinkles. Using a sponge, I then apply hot rabbitskin glue. The formula consists of six level tablespoons (42.5 grams) of granular glue dissolved in one quart of water at 20° to 40° below the boiling point of 212° F. The wet glue leaves the canvas as tight as a drum and dries within a few hours. I then usually sandpaper the surface to remove any rough spots and I size it again, using much less glue.

After it has dried for the second time, the canvas is ready to be

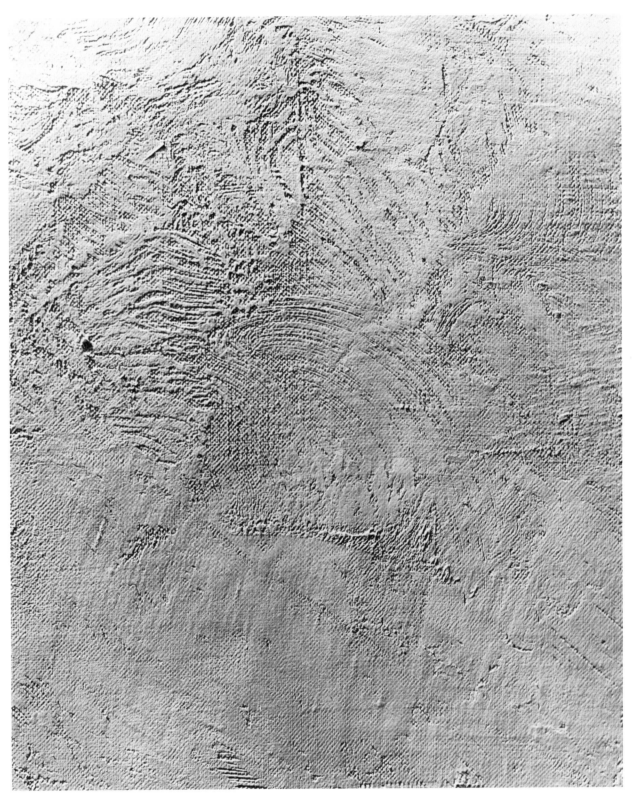

Canvas Texture (Grounds). In this detail of a primed canvas, I brushed on white lead in a generous layer, some 1/16″ (2mm) thick. After the turpentine evaporated, I reworked the texture with a 3″ (76mm) knife in three basic methods. In the lower half of the canvas, I achieved a smooth effect by drawing the knife lightly across the priming. In the center, I scraped lightly down to the canvas itself, and in the upper left-hand corner, I smoothed the peaks of the impasto brushstrokes.

primed. I prefer priming made up of pure basic carbonate of lead, available in paste form under various brand names, such as Dutch Boy Lead. Since white lead is now difficult to obtain due to federal regulations concerning its possible poisonous qualities, an alternative is flake white, a common artists' pigment, sold in one-pound tubes. I thin the white lead with pure gum spirits of turpentine to a heavy consistency and brush it deeply into the canvas with a stiff 4″ (102mm) housepainter's brush. I cover the canvas thoroughly, allowing the texture of the brushstrokes to stand on the surface. The turpentine evaporates within ten minutes or so and the white lead regains its original paste form. I then work over the surface with a large palette knife, scraping and smoothing the surface to achieve whatever texture I want. This scraping must be done quickly and at the proper time before the priming grows too hard to manipulate easily. If done too soon—while the paint is too soft—it may produce a surface too smooth and lacking sufficient tooth to hold subsequent paint layers.

I prepare batches of canvases twice a year, usually 30 or more canvases and an equal number of hardboard panels at a time. I size the panels on both sides to avoid warping, then prime them exactly as I do the canvases. About ten days of drying are required for both grounds, depending upon the humidity at the time they are prepared—it's best to do it in periods of average humidity. I note the priming date on the back of each canvas and panel, so I can use those first that have aged the longest.

Brushes

For most of my work in oils, I use the bristle brushes of the kind known as filberts. The filbert shape is a compromise between the flat and round brush in that the tip is tapered and rounded at the edges. I use sizes #2, #4, #6, #8, #10, and #12. I also use the extra long filberts, sometimes called egberts. Besides, I use some large, flat bristle brushes; #2 round sables for detail; and #6 sable and badger blenders, mostly to flatten heavy brushstrokes that may cause excessive glare within dark areas.

Knives

The painting knife isn't easy to control, but when it is mastered it can be used to create effects that are difficult to obtain with brushes. Mine are 1″ (25mm) and 3″ (76mm) elongated triangles rounded at the tip. Some artists use the knife like a trowel and the resulting effect is not unlike a stucco wall. But when the knife is used in conjunction with skilled, interesting brushwork, the painting surface assumes a marvelous spontaneity.

When I am painting outside in the winter, the paint is apt to become very stiff from the cold, and a good, sturdy knifeblade is the only practical tool for manipulating pigment without resorting to excessive dilution with solvents or mediums.

Paints

I use only 12 colors for my outdoor painting, as compared to the 20 on my studio palette. The 12 are a lot for outdoor work and I often make do with less. Black could easily be eliminated, but I keep it in the box for convenience. Before elaborating on the colors I use, some comments on oil paints in general might be useful.

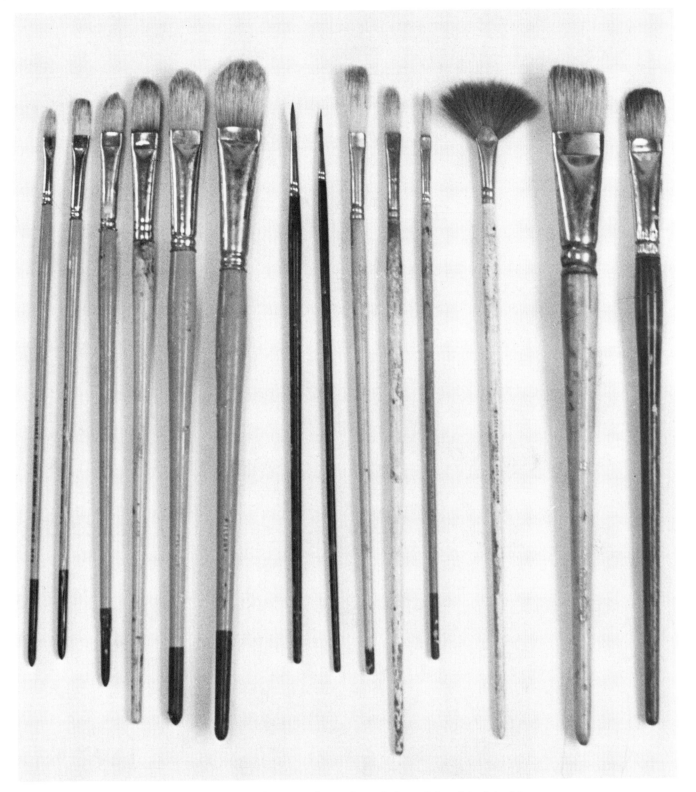

Brushes. The brushes I use for outdoor work are, from left to right: #2, #4, #6, #8, #10, and #12 filbert brushes; #10 and #4 round sable brushes; #8, #6, and #4 long bristle egbert brushes; a #6 sable fan blender; and #12 and #10 flat bristle brushes. I think it unnecessary to carry more than this for average subjects. In fact, I rarely use them all. I could probably make do with merely a small and medium filbert and leave the rest at home.

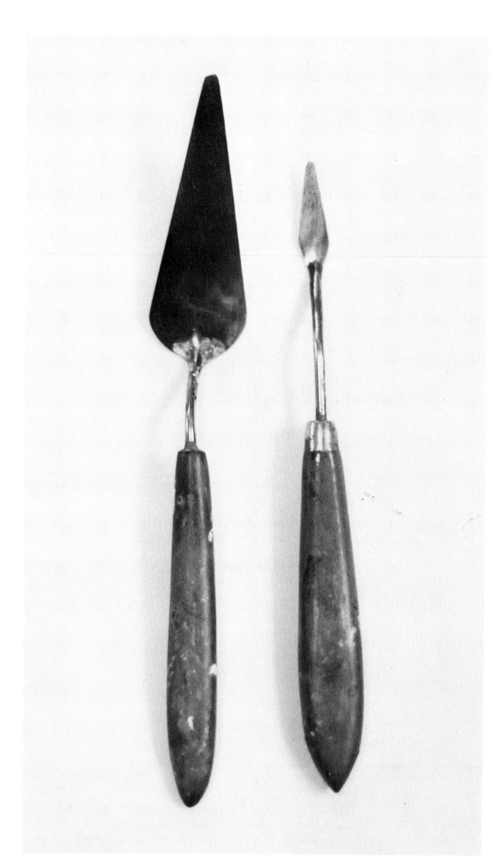

Palette Knives. In landscape painting, the only two knives I find necessary are this 3″ (76mm) large knife and the 1″ small one. It's necessary to dull the edges of these blades periodically, since an inadvertent knife stroke can easily slash the canvas and ruin it.

To begin with, oil paints differ in quality even within specific brands. Most manufacturers offer a so-called "student" grade and a "professional" grade. Student-grade paints are cheaper than, and in most cases inferior to, the professional grade. Professional-grade paints usually contain pigments that are more carefully ground; these also contain more pigment in proportion to the amount of oil as well as less of the additives needed to improve the working qualities of the paints.

The artist's best assurance of quality and permanence is a thorough knowledge of his materials. My way is to test the various brands as to their performance. Periodically, I subject a random sample of all the pigments to light tests by exposure to direct sunlight for a period of three months. By comparing these exposed samples to others that have been kept covered, I discover which are susceptible to fading. This way, I occasionally find that a pigment designated "permanent" has undergone an unacceptable degree of change. Naturally, I will eliminate it from my palette. After conducting many such tests, I think that most American brands of oil paint are as good as the European product.

Palette

My basic landscape painting palette consists of these pigments:

White (Titanium and Zinc mixture)

Cadmium Yellow Pale

Yellow Ochre Light

Cadmium Scarlet

Terra Rosa

Alizarin Crimson

Burnt Sienna Deep

Viridian

Cobalt Blue Light

Ultramarine Blue Deep

Cobalt Violet Dark

Ivory Black

White and Black

I prefer the titanium-zinc white mixture because titanium dioxide is the whitest of the white pigments, while zinc oxide adds good strength and brushing qualities. Ivory black is more workable and doesn't dry as dull as lamp black, but because of its relatively high oil content and long drying time, ivory black must be used with caution, particularly in underpainting, when it should be used as a thin wash.

Cadmiums

All the cadmium sulfide colors are stable, brilliant, and completely permanent. By adding their complementary colors (see the color diagram

Outdoor Palette. The palette shown above is a 3/16″ (4.8mm) piece of Masonite Presdwood, measuring 16″ x 20″ (406mm x 508mm). It fits neatly into a slot inside my paintbox. There is a 1″ space between the surface of the palette and the inside of the box, so I can prepare the palette in the studio and gain a little working time in the field, since the paint won't be disturbed when the box is carried. The surface of the palette is rendered nonabsorbent by a light coat of clear shellac. Starting at the top left the colors are: ivory black, cobalt violet dark, ultramarine blue, cobalt blue light, viridian, burnt sienna deep, alizarin crimson, terra rosa, cadmium scarlet, yellow ochre light, cadmium yellow pale, and titanium white.

on p. 27) or earth colors to the cadmiums, I can match all the other reds—
except the cool, transparent alizarin crimson or the madder lakes (which
are fugitive and have been replaced by the more permanent alizarin on
modern palettes).

Earth Colors

All the earth colors are absolutely permanent; however, they may
vary widely in value from brand to brand. Similar shades of red may be
labeled terra rosa, Venetian red, Indian red, English red, light red, Mars
red, and flesh ochre. The best way is to find a suitable brand and stick
with it. I use Utrecht yellow ochre and Grumbacher terra rosa. My burnt
sienna is a Belgian-made Blockx color. I combine it with ivory black for
beautiful, warm, transparent darks.

Cobalt Blue and Violet

The blue I use most, especially in my lights, is cobalt blue, since it is
absolutely permanent. I mix it with white, viridian, or cadmium yellow
to duplicate greener blues such as cerulean or manganese. I use cobalt
violet dark; it can be used in perfect safety straight from the tube or
mixed. A touch of white will give you a color a bit cooler than cobalt vio-
let light. Also, cobalt blue works well with other blues. Mixed with other
colors than whites or blues, it hardly affects the other colors, due to its
low tinting strength. Cobalt violet light must be handled carefully be-
cause it contains arsenic in the form of arsenate of cobalt.

Ultramarine Blue

Ultramarine blue is cooler and not quite as durable as cobalt blue,
but its singular warm hue and deep transparency cannot be duplicated.
When properly handled, ultramarine blue is about as permanent as any
color on my palette. However, it must be kept away from acid. Most com-
monly, damage from acid occurs where sulphur dioxide is present in the
air. A coat of damar varnish is the most convenient precaution against
airborne acid damage. Naturally, a painting should never be cleaned
with acid compounds.

Alizarin Crimson

Alizarin crimson was once regarded as semi-permanent due to its
tendency to grow increasingly transparent upon excessive exposure to
light. Common sense therefore dictates that it should be avoided in thin
or weak mixtures, and a painting containing it should not be hung in di-
rect sunlight, even for a few hours.

Color Permanence

With these minor exceptions, the colors on my palette are perma-
nent under normal conditions. By "normal," I mean helping to assure
permanence by taking such precautions as applying a protective coat of
varnish; keeping the picture away from direct sunlight and airborne cor-
rosives; never placing it over a radiator or other heat source or having it
cleaned by an unskilled person. Only alizarin crimson consistently dis-
played any change when I conducted my light tests, but with proper care,
it too can be included among the family of permanent colors.

Mediums

Painting mediums are designed to serve a dual purpose: to give oil paint a fluid consistency so that it can be manipulated more easily; to dilute small amounts of paint to use as transparent glazes.

Any medium added to paint straight from the tube will reduce the strength and brilliance of the pigment, since most manufacturers strive to achieve an ideal balance between the oil and pigment content of each tubed individual color; when this proportion is altered, there is a loss of quality in the paint. I have never resorted to using mediums in my work despite having experimented with all the well-known (and with most of the lesser-known) mediums designated for oil painting. By employing such techniques as drybrush or scumbling, I can duplicate almost any of the effects that mediums help to achieve. If I want to thin my paint—which may occur in the early stages of the painting—I use pure spirits of gum turpentine, which evaporates almost entirely, leaving the original paint relatively unadulterated and unlikely to yellow from excessive oil. And since my method of painting is basically direct and doesn't involve the gradual buildup of layers of paint, I don't concern myself with the possible weakening of the paint film attributed to excessive thinning with turpentine.

To those who insist on employing a painting medium, I recommend that provided on p. 216 of Ralph Mayer's *The Artist's Handbook of Materials and Techniques* (3rd edition).

Varnishes

Once I return the painting to the studio for final touches and corrections, I do use retouch varnish. This final reworking is always kept to an absolute minimum to preserve the spontaneity of the brushwork. On areas gone flat, I spray retouch to regain their true value. However, I use it most sparingly, so that it won't form a coat as heavy as that produced by the final varnishing. I put the completed painting in a dust-proof rack until the canvas is thoroughly dry. Five or six months later, I apply a final, thin, even coat of damar varnish with a brush. Although I have given some of my paintings their final varnish just two or three months after completion, none have cracked or shown other damage due to this early final varnishing.

Rules of Permanence

The basic principles that assure permanence in a painting are founded on common sense and a sound *working* knowledge of one's materials. The rules of permanence do not inhibit creativity in the slightest way. Craftsmanship should be so ingrained that all attention is directed to the effort at hand. It's more important to know *how* materials function than *why* they do so. For the most cogent remarks regarding permanence, I recommend the section in Ralph Mayer's *The Artist's Handbook of Materials and Techniques* entitled "Simple Rules of Permanence" (p. 169). The rules and procedures ensuring permanence apply equally to studio and outdoor painting.

Painting Outdoors

The mainstay of outdoor painting is a good, rigid easel that can be set up quickly. Without such a stable support, the work is nearly impossible. My easel is an army surplus tripod that cost just three dollars. Originally, it was probably used to support optical range-finding or surveying devices. I altered it slightly to support the bottom and top of my canvas. It can hold everything firmly from an eight-inch panel to six foot canvas; it can angle about 20° forward or backward, and can raise a 20″ x 30″ canvas from the ground level to my eye level when I am standing. It's as solid as a rock, and in 15 years of use I have yet to lose a canvas to the wind. The only drawback is that it weighs much more than a standard sketching easel.

Paintbox

My paintbox is the standard wooden case with the usual sections for a wet palette, brushes, paints, etc. I fitted the bottom of the paintbox with wooden legs that fold up neatly when it is being carried. When the legs are unfolded and locked in position, the paintbox is, in effect, a portable taboret that serves as a stable platform for my palette and turpentine can. My easel, when folded, can be strapped to the paintbox and both can be carried by a handle or shoulder strap, leaving my hands free to carry a wet canvas or help make my way in difficult terrain. Usually, I can set up and start painting in about three minutes. This is important since the time saved getting ready can be used for painting. This will be discussed in more detail later.

My paintbox includes a pint can of pure gum spirits of turpentine, fitted inside a rectangular quart-sized can. The top of the larger can has been removed and a strip of ¼″ (6.3mm) wire mesh lines its bottom. This layer can is filled with turpentine when I am painting—the mesh enables me to clean my brushes quickly, which is terribly important since a dirty brush makes it nearly impossible to achieve clean color. I also carry about a dozen clean rags precut to a convenient size—about 18″ x 18″ (457mm x 457mm)—another indispensable factor in obtaining clean color.

The only other items are my two knives, a small pair of pliers, a pocketknife, and a paint scraper for cleaning my palette, just as important for clean color, since whatever is on the palette eventually finds its way onto the canvas. I usually clean my palette every 15 minutes or so. A lot of paint is lost in the process, but the object of art is not the saving of paint.

Winter/Summer Painting

There are few basic differences between winter and summer outdoor painting, most of which merely concern inconvenience. This, however, is of little consequence to the artist. To paint a convincing winter landscape, you must work with both feet in the snow—comfort is of little importance.

I have encountered three problems in winter painting. First, because the day is shorter, an early start is important. Second, it is often necessary to work with warm gloves, which can be cumbersome. I usually alternate, working with gloves for the block-in and broad areas, then removing the gloves for detail work. Third, the consistency of oil paint changes

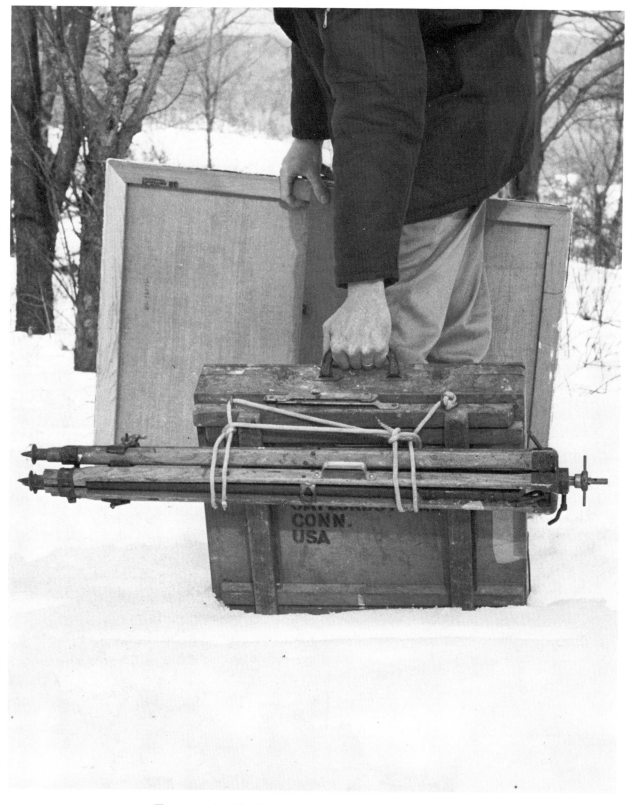

Transporting Outdoor Materials. Here, the paintbox and easel are folded and secured together for carrying, leaving my right hand free to carry the canvas. I prefer to carry the canvas separately, particularly when the painting is finished, because it is often somewhat tricky maneuvering a wet canvas when trudging through heavy brush or difficult terrain. The box and easel can also be fitted with a strap and carried over my shoulder, leaving both hands free.

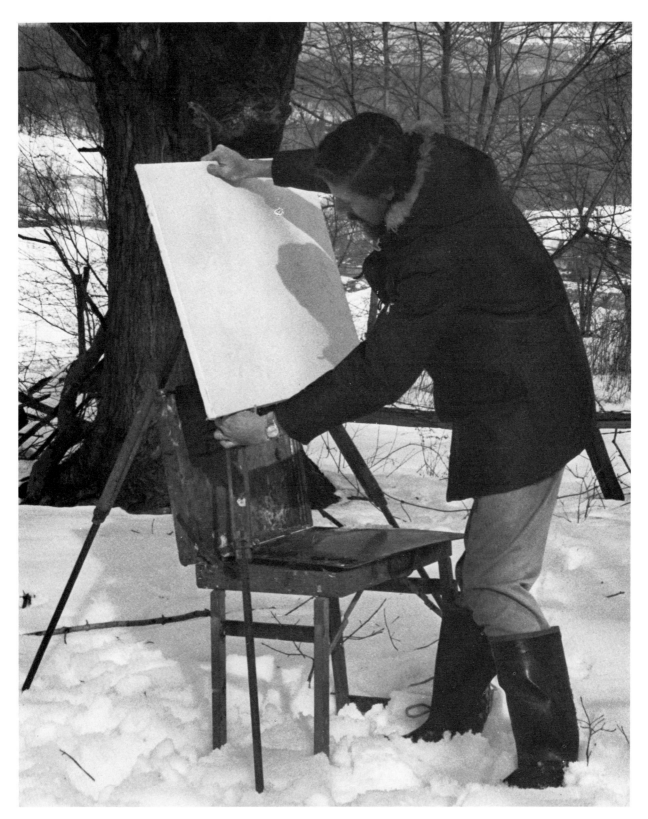

Setting Up Outdoor Materials. With the paintbox unfolded and the palette nesting on top, the easel can be fully extended over them. Here, a slightly larger than average canvas is being fitted to the easel. This entire setting-up process takes only a few minutes. Notice that I am casting a shadow on the canvas, meaning of course, that the canvas is in full sunlight. In practice, I would never set up in this position but it is being shown this way for photographic purposes.

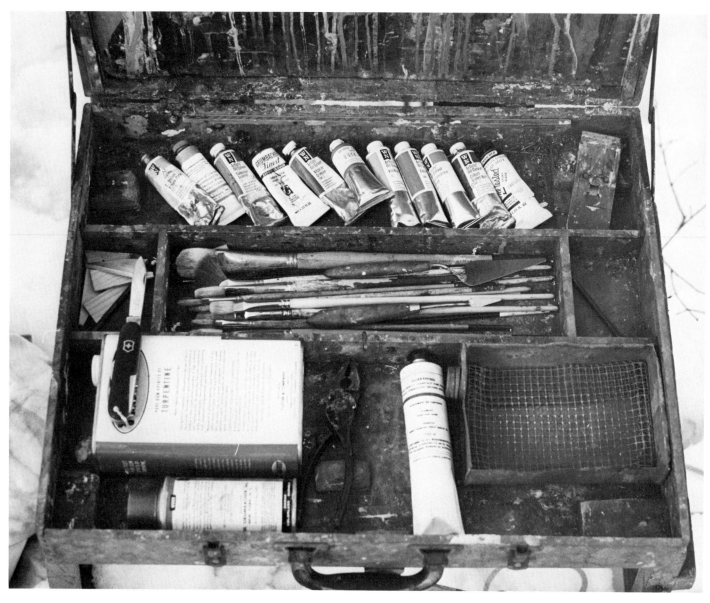

Paintbox Contents. The only missing items from this collection in my paintbox are the rags normally stuffed into the empty spaces to keep things in place while the box is being carried. At the top are the tubes of paint and just to the right is the palette scraper. In the center left are a few wooden keys. The adjoining compartment contains all the brushes and palette knives. The lower section contains, from left to right: a can of turpentine with a pocketknife on top and a spray can of retouch varnish, a pair of pliers, a tube of titanium white, and a can with wire mesh (to be filled with turpentine) for cleaning brushes.

in low temperatures, causing the paint to lose its plasticity and rendering it stiff and unworkable. Adding small amounts of turpentine will usually restore the paint's working qualities. The rule, of course, is to use the least possible turpentine especially in heavy, impasto brushwork. Rather than add too much turpentine, it might be better to substitute a knife for the brush. It is sometimes suggested that alcohol be added to the oil paint in cold weather. To the *painter*, perhaps; to paints, never.

Summer painting poses no real problems. A wide-brimmed hat and insect repellent are the only extras I take with me or possibly a large, white beach umbrella, which provides pleasant, diffused sunlight to work by, as well as privacy from spectators whose comments hardly help the painting.

Color

Dozens upon dozens of books are written about color as it applies to art. But while you can make fairly consistent, generalizations regarding some other aspects of painting—drawing, edges, values, etc.—color is such a personal, subjective factor that it defies precise analysis. Some artists are aware of color while others are indifferent to it. When I paint from life either indoors or outdoors, I only need to know how to mix the proper pigments to reproduce the colors I see before me; I know that if I do this accurately, the picture will re-create the harmony of the subject, which the light source itself renders *naturally* harmonious.

There is no reason for an artist to be overly concerned with color; if he chooses to play down this area and emphasize the other elements of the painting, that is strictly his own affair and no cause for criticism. The creative process is difficult enough without sacrificing all of one's efforts to a single aspect of painting that is complex enough to discourage any painter, particularly the beginner.

Learning Color

The only way to learn about color (in art) is to see how it behaves in actual painting practice. One way is to make combinations of all the colors on your palette in slowly graduated mixtures. Take the twelve basic colors on the palette and mix each color with each other color, varying the proportions until you have a number of mixtures that run from the lightest to the darkest. Repeat this procedure with every color until you have exhausted all the possible combinations which, if you are persistent enough, can add up to hundreds.

While this may seem terribly tedious, it can be also extremely informative. Not only will you learn how each of your colors appears in mixture with the other colors, you will also gain valuable insight into the way each color behaves as to drying time, tinting strength, covering power, etc. By the time you have completed this experiment—and put these mixtures down on charts—you will have learned a great deal about color.

Principles of Composition

The only "rules" of composition I accept are the principles *underlying* these "rules": namely, to attract the viewer's attention, to direct it to the important area of the painting, and finally to hold his attention there as long as possible. Any method used to accomplish this objective is legitimate.

There are three basic compositional qualities that are consistently evident in my work and in that of the artists who have influenced me. The first is an overall *simplicity* regardless of the size of the painting or the complexity of the subject matter.

The second is *harmony*—the presence of a single pictorial element that acts as a unifying device. In most cases, it is a single source of light on the subject. However, any other device will be as effective: an overall tonality; color-related areas; an integrated linear pattern; precise control of edges; or a subdued combination of all these elements, perhaps with one of them somewhat more obvious.

The third quality of composition I seek is *subtlety*. A pictorial composition that is obvious defeats its purpose. Composition should merely be an element of a total effort and every element must remain subordinate to the representation of the subject.

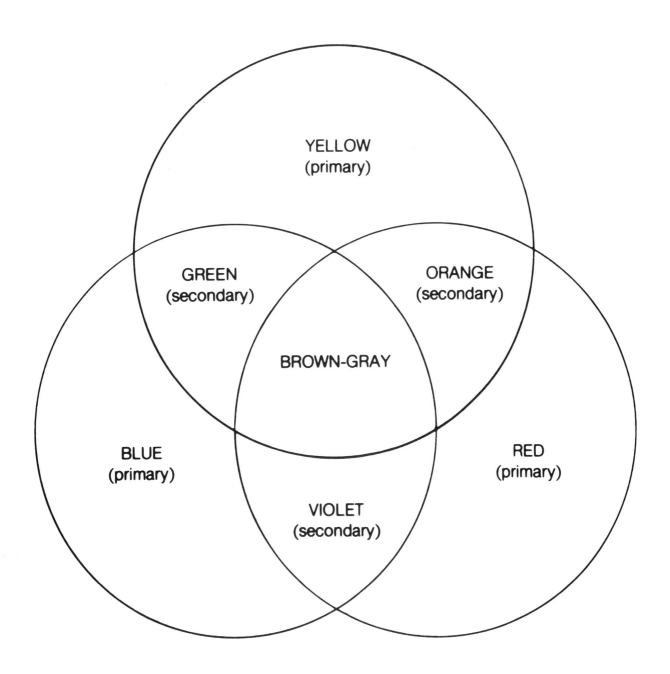

Color Diagram. When describing color mixtures, these terms are used. The *primary* colors—red, yellow, and blue—are basic and cannot be duplicated by any other colors. The *secondary* colors—orange, green, and violet—are formed by mixing any two of the primaries. When all three primaries are mixed the result is a "neutral" color that can generally be described as "brown-gray" in hue. Any two colors that fall opposite each other on the color diagram are called *complementary* colors as for instance, yellow and violet and red and green. When complementaries are mixed together they tend to cancel each other out, also producing a neutral effect.

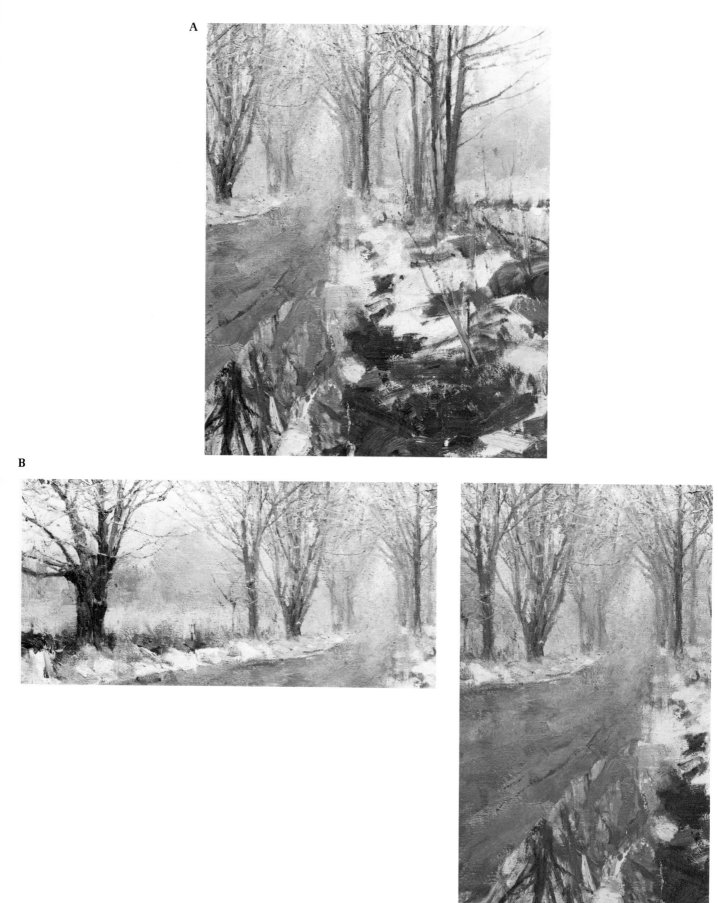

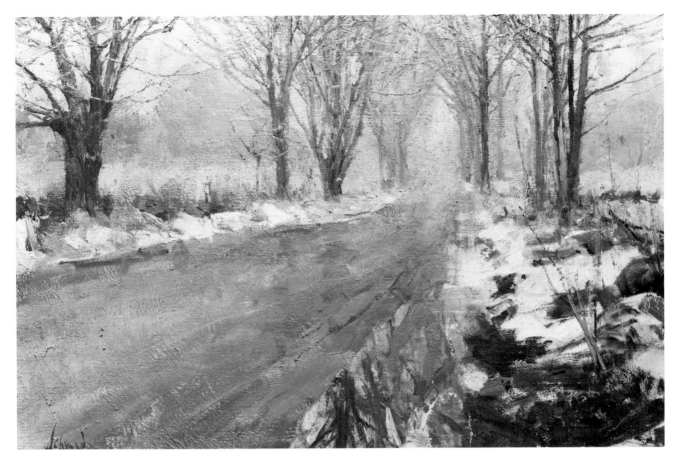

Compositional Variations A, B, C, and Final. (Details of *Spring Lake Road*)
Demonstrated here are three compositional variations and the final version of a
sketch of a country road in winter. I'm not sure how much can be said (if any-
thing) about the relative merits of any one version over any other. It seems a
simple matter of personal taste. None of these compositions is particularly radi-
cal. My final choice was based on what I chose to emphasize. In Variation A, the
foreground and the trees on the right are stressed. In B, the strong, old maple on
the left is dominant. In C, the vertical composition creates a tunnel effect, as the
road and trees recede into the distance. I decided to combine all these aspects
into a single composition and the result is seen in the final painting. At this point
in my development as a painter, my decisions on composition are largely in-
stinctive.

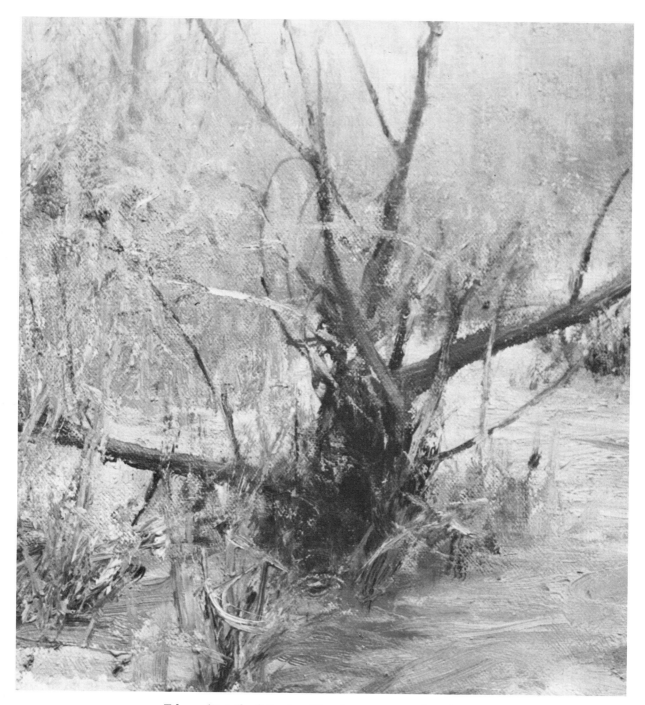

Edges. (Detail of *Spring Floodwater*, reproduced on p.112) There is no such thing as a line in nature. There is only form revealed by various light conditions. It is this combination of light and form that determines the character of edges in any given situation. While edges alone don't make a painting, failure to understand them practically ensures failure. In this example, there is a multiplicity of overlapping elements under soft daylight. Every degree of sharpness and softness is represented here. Each of the four main branches in this detail runs the gamut of edges of from razor-sharp to completely lost. The knife was used extensively for the sharp edges, particularly in the lower middle section. In landscape painting where there are literally millions of interlaced individual leaves, branches, grasses, etc., I find the only practical way to deal with what I see is by determining the *pattern* of edges. This applies especially to the moving water in the foreground and middleground.

This constitutes the extent of my theories regarding composition, except to point out that there is no limit to the possible arrangements of compositional elements within a picture. Remaining within the bounds of simplicity, harmony, and subtlety, the artist has endless latitude for discovering compositional devices to stimulate new ways of seeing. He should look beyond the "safe" and the "tried and true." There is nothing wrong with playing it "safe," except that it is dull and eventually it halts growth in perception.

Edges

Wherever two or more different forms, values, or colors meet, an edge is formed. Every shape contains edges. The hardness or softness of an edge is determined by the "speed" of the transition between the two adjacent forms, values, or colors. Where the transition from one to another is "slow," gradual, or subtle, it produces a soft or lost edge. A "rapid" or abrupt transition produces a hard edge.

Like changes in color, edges can be used instead of value changes to indicate form. Together with color harmony and value control, edges help to unify a painting. A most arresting focal point can be created by placing the lightest light, the darkest dark, the strongest colors, and the sharpest edge at the same juncture on the canvas.

Values

The value of color is its degree of lightness or darkness measured on a scale from black to white. For all practical purposes, I work with the following nine values in the range from white to black:

1. White (lightest light)

2. Light Halftone

3. Light Halftone

4. Light Halftone

5. Middle Tone

6. Dark Halftone

7. Dark Halftone

8. Dark Halftone

9. Black (darkest dark)

Obviously, there are many more than nine values in nature, but until someone develops a practical method of painting with light itself, these are all we have to work with.

Outside the range of nine values open to us, most of the values in nature occur beyond white paint. This has created no end of frustration for those who attempt to paint things "whiter than white"—who try to duplicate the brightness of the sun with the colors available to man. Eventually, an artist must settle for painting the *effect* of light, rather than the light itself. Painting the *effect* of light is not really a compromise since the goal of landscape painting is not to duplicate nature but to make a meaningful statement about it through the medium of paint. Yet we know what startlingly realistic results can be achieved when the full po-

Value Scale. These nine values or intervals between white and black begin with #1, the lightest light (white), and continue through #2, #3, and #4 (light half-tones), #5 (middle tone), #6, #7, and #8 (dark halftones), to #9, the darkest dark (black).

tential of values and color are understood. This will be discussed at greater length in the following pages.

Modeling with Color

Modeling means the use of values, color, color temperature, and edges to achieve a three-dimensional effect. In full-color painting, the changes of value can be represented by other means, such as varying color temperature to accomplish the same effect. This is done by adding cooler or warmer colors *of the same value* to the original tone.

Modeling a form by using a variation in color temperature to represent a different value was a device employed by the Impressionists. Many Impressionists so stressed color and underplayed values that their work appears weak when seen in monochrome, yet holds up well in full color.

Optical Aids and Photography

Photography as an aid to painting wasn't part of my procedure until several years ago when my normal painting activities became sharply limited due to an injury to my spine, which became a more or less permanent disability. Lifting and carrying my usual equipment was impossible, so using a camera became a natural expedient. Instead of executing a large canvas in the field, I had to confine my procedure to painting smaller, quick sketches on the spot. I would then return to the studio and execute a larger canvas, using my color sketches, photographs, and memory for my working material.

This would appear to interfere with my practice of *alla prima* painting, but it does not. I still complete a painting in one working session. For a larger canvas, the session is merely extended. In many cases, the color sketch is a finished work in itself.

Disability or not, I think I would have experimented with and finally adopted photography into my normal working methods. Fortunately, I have never had scruples about using photography because for me, it never became a substitute for seeing.

There is a notion among many that the use of mechanical or optical aids in painting is somehow bad form. Photography in particular is sharply denounced. This is unfortunate, since I think photography is an invaluable tool for painting. Artists are forever seeking new ways of

seeing, and many optical devices were used by the old masters. Leonardo da Vinci was deeply involved in researching the laws of optics; the *camera obscura* he helped develop was employed by Vermeer and some of his contemporaries.

But photography, like wine, must be used with discretion lest it become a crutch. There is no substitute for working from life and I would discourage anyone from using photos until he has first put in years of painting from life. Being two-dimensional, photography can destroy the artist's ability to paint the illusion of depth. Even after many years of painting from life, an over-dependence upon photographs can prove highly detrimental. Another serious drawback of film is its relatively narrow range of color and value. Low values and dark colors tend to merge in photographs; colors in the light, above a certain value are simply washed out. Nor can the problem be solved by combining one slightly overexposed and one underexposed photo, which merely compounds the difficulty by presenting two *wrong* views of values and colors instead of one. Only a thorough knowledge of the values and colors of a subject in *life* can ensure a convincing rendition of the same subject from a photograph.

Besides photography, the only optical aid I use is an ordinary mirror. Seeing a painting in reverse image quickly reveals mistakes in drawing and value. The most common and persistent drawing errors occur in the horizontal and vertical alignment of the drawing. The fact that artists are right- or left-handed leads to an unconscious slanting of perpendicular lines; such mistakes are best detected by viewing them in reverse mirror image where they become immediately apparent.

A so-called "black" mirror—a piece of glass painted black on one side—can also be helpful, particularly to the beginning artist. This device exaggerates highlights and other values in the light. However, the black mirror shows these values only in relation to each other and not as they actually are, it must be abandoned once the artist gains a firm grasp of true value relationships.

There are other mechanical and optical devices that I regard as unnecessary and often clearly harmful. Among the harmful practices is viewing a painting through a reducing glass. Since a picture always looks better when it is greatly reduced in size, anyone who resorts to a reducing glass is merely deceiving himself.

Linear Perspective

Perspective is usually presented as a complicated system of interacting factors: converging horizontal lines, vertical lines, horizons, multiple vanishing points, station point, picture planes, conical projection, etc.—the list is a very long one. This is all necessary for the architectural draftsman, but most of it is useless for landscape painting. Many of the finest landscape painters in history had no awareness at all of linear perspective; what they did have was an eye for the obvious and therefore, a sense of perspective, which is what matters.

In my training, I received the full course in perspective, out of which I gleaned only four useful ideas. First, objects in a landscape appear to diminish in size as they recede from the viewer. Second, the horizon is always at the eye level of the viewer, even though it may be obstructed by a hill or some other element. Third, parallel lines on geometrical objects

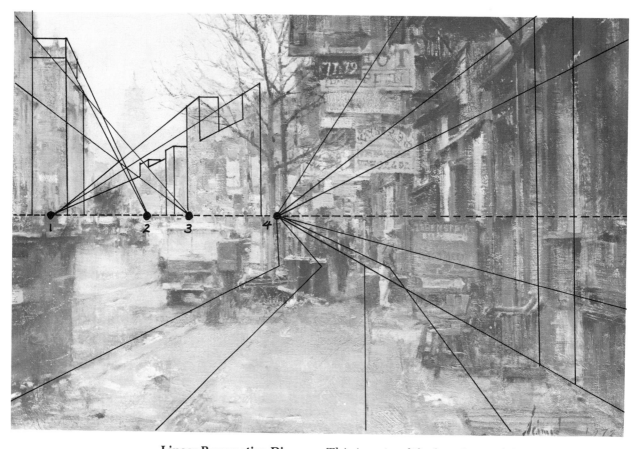

Linear Perspective Diagram. This is a simplified analysis of the elements of perspective in *Manhattan Street* (see p.123), a typical street scene. Like most older streets, this one doesn't follow a straight course. In this view, it makes several slight turns to the left. Consequently, there are four vanishing points along the horizon line (the dotted horizontal line halfway up the canvas). The horizon line on a level plane such as this street, will always be at eye level. Since the buildings along the street are parallel to the street, the vanishing point of their perspective lines changes with each jog of the street.

(such as buildings) tend to converge in the distance, usually at the horizon. Fourth, when one (or more) of the first three principles doesn't seem to be present, I ignore it and paint what I see.

There is a great deal more to be known about perspective and there are many excellent books on its finer points. The two best discussions of perspective as applied to landscape work are in *Carlson's Guide to Landscape Painting*, section seven, and *Optics, Painting and Photography* (see Bibliography).

Aerial Perspective

Besides the linear aspects, the effect of distance in landscape is achieved through color and value changes. There is generally a tendency for colors to become cooler and grayer as distance increases. Contrast also seems to diminish. This is by no means a rigid principle for nature is far too complicated to bend to rules—which is why I always choose to paint *what I see, rather than what I know.* I have painted in conditions where weather, terrain, time of day or year, local color, and geographical location have all combined to make a shambles of the principles of aerial perspective.

Aerial perspective fails completely when artificial light is involved. When I lived in the city, I frequently painted street scenes using the illumination of a street light or a shop window to work by. Painting at night presents its own lighting problems. Most major cities use sodium or mercury vapor lamps for street lighting. While these lights are very bright, there are gaps in their spectrum and the color of the light is either a deathly purple or yellow-green. This light is impossible to use for mixing colors or illuminating the canvas.

In Chicago, I found the only decent lights to work by were the incandescent lights beneath the bridges over the Chicago River. At that time I painted in the company of two or three other artists and we spent so much time under Chicago bridges that we became known as the Troll School of Art.

Painting in Direct Sunlight

Direct sunlight is the basic ingredient in landscape painting. Its quality, direction, and duration determine the colors, forms, values, and working time available for painting—particularly in *alla prima.* For the purpose of this discussion, I have divided sunlight into three forms: direct sunlight, overcast, and open shade.

Direct sunlight is probably the most difficult illumination to work with, since it takes so many different forms. For example, the available painting time in the early morning and late afternoon is much shorter due to the rapidly changing pattern of cast shadows as the angle of light grows increasingly acute. The effect of the earth's rotation relative to the sun is more pronounced at that time than at midday. Atmospheric effects are also exaggerated. In the late afternoon and early evening, as the sun lowers in the sky, the sun's rays must pass through increasingly dense atmosphere, producing accelerated color and value changes. These same changes occur in reverse during the morning: if a painting is started at 7:00 A.M., the angle of sunlight has changed by 45° by 10:00 A.M., enough of a difference to require repainting of all initially placed cast shadows.

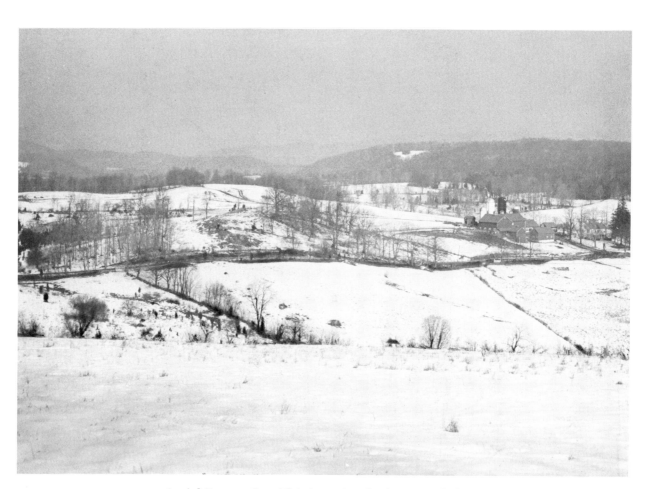

Aerial Perspective. This is a view looking north from my studio on a January day. The sun is behind me and the atmosphere is heavy with moisture presenting an ideal example of aerial perspective. There is a typical progression from clarity in the foreground to almost total obscurity in the distance. The distant haze augments the effect, but even on a clear day, there is the progression toward reduced contrast as distance increases, except that distant edges would be somewhat sharper and the colors would be cooler. Aerial perspective is by no means a rigid law of nature, but merely a guiding principle. I can think of many examples where it is completely reversed. A striking example is in the works of many oriental masters. In many of their paintings, the foreground is entirely lost in mist and distant objects emerge with stunning clarity. Never take anything for granted when dealing with nature.

Direct Sunlight. Direct sunlight usually, but not always, produces high contrast effects, depending upon the subject, the angle of the sunlight (the time of day), and the observer's position in relation to the direction of the light. In this example, everything comes together to produce a high contrast effect—the brightness of the snow, the dark trees, the strong cast shadows, etc. In direct sun with a slight haze in the atmosphere and a subject with elements similar in color and value, the contrast would be greatly reduced. When painting directly into the sun, the effect is almost all contrast, with few middle tones. What is seen is only the bright glare of the sunlight and the shadow side of everything in its path.

The example I have just given occurs when the sun is traveling across my line of sight, from my left to my right or vice versa.

There are two other direct sunlight situations: painting directly into the sun and painting away from the sun (with the sun behind you). Painting into the sunlight creates problems of seeing, caused by the intense glare of the light on the subject and the relatively low level of light on the canvas. This causes the pupils of my eyes to close and widen alternately as I constantly glance up at the subject and then down at my canvas. This is not only hard on the eyes, but makes accurate judgment of values and color very difficult. The solution is to slow down and give the eye more time for adjustment. It is also helpful to step back several yards from the canvas, study the subject from *that* position, and make judgments about values and color.

The only difficulty of painting with the sun behind you is finding a vantage point where the sun will not strike either the canvas or the palette. This is easily done by setting up in an area of open shade. If no shade is available, a large *white* beach umbrella will do as well. It is important that the cloth on the umbrella be semi-transparent. This creates a bright, diffused light to work by. (An ordinary bedsheet is ideal for this purpose.) By experience, I have found that when I paint with direct sunlight on my canvas, an unconscious compensation occurs that affects the values and colors of the painting. Because of the intensity and warmth of sunlight, all my mixtures appear to be several notes lighter and warmer until I get back to the studio; then, when I view the work under average indoor light, I find that the overcompensation has produced a painting much darker and cooler than the actual subject. The painting will, therefore, appear correct only if it is hung in direct sunlight or in high-intensity incandescent light. Both such light sources, however, will be disastrous to the permanence of the painting in a short period of time.

While direct sunlight is one of nature's most stunning gifts, to work with this light successfully it's only necessary to anticipate the pitfalls and select an appropriate procedure and vantage point.

Overcast

Overcast is sunlight diffused through a relatively even cloud layer. The quality of this light depends mainly on the density, thickness, and altitude of the clouds. It is further affected by the time of day, time of year, and to some extent, by geographical location. Of all forms of natural light I prefer a high, bright overcast. To begin with, it is the most stable of all natural lighting. Usually, an overcast sky will prevail all day, providing maximum painting time. When the overcast does change, the change is slow and predictable. Besides, it diffuses sunlight evenly and

Overcast Light. We are all partial to one thing or another and my weakness is for the gentle quality of overcast light. It is Nature at her most benign. Under this quiet illumination, nearly anything can be painted, which doesn't hold true under other natural or artificial illumination. Direct sunlight, for example, is far beyond the range of anyone's palette. In the example above, there are no hard shadows or extreme points of glare, yet the contrast is satisfying. The modeling and value transitions are subtle but definite. Another advantage of overcast is that it usually remains constant, providing a wide margin of extra painting time.

because of this there is no definite light direction. The sun can travel for hours above the overcast with no discernible change in the landscape.

Another important benefit of overcast is that the same light that falls on the landscape also falls on the canvas and palette, precluding any adjustments in seeing or mixing colors. A painting done under overcast will look "right" under almost any illumination.

Finally, besides enhancing local color (the color of things as they appear to a normal eye under a balanced spectrum illumination) overcast light actually helps me judge color in the same way that north daylight does in the studio. This happens because overcast is relatively cool and cool light creates relationships in color temperature that work with me as I mix paint. In cool light such as overcast, colors on the subject appear cooler as they become lighter, and warmer as they become darker. In mixing colors, the most common way to lighten a color is to add white. Since white is the coldest of all pigments, I actually *cool* the mixture as I add white to lighten it. In a real sense, the light and the paint work together to facilitate the mixing of color.

By contrast, warm light—such as direct sunlight and incandescent light—is not as helpful. In warm light, colors appear warmer as they become lighter and cooler as they darken, so the problem of mixing paint colors in warm light becomes how to lighten colors without also cooling them. White, being a cold pigment, is inappropriate by itself. This dictates painting the *effect* of the color relationships on the subject rather than the actual colors. One way is to exaggerate the coolness of the darks or adjacent colors to make the light appear warmer by contrast.

Open Shade

Open shade is usually very cool, since it occurs when there is sunshine and a clear, blue sky. The light that strikes the canvas (the working light) is therefore predominantly blue, which creates no problem if the subject is *also in open shade*. However, if the subject is in bright sunlight, it becomes very difficult to judge color temperature on the cool light of the canvas against the sunlit landscape. The solution is to make all the warm tones (those that occur in the light) a note warmer on the canvas to compensate for the cooling effect of the blue light. The blue light also exaggerates all cool color mixtures, making them appear slightly more blue than they actually are. But I have found that it is best to paint these cool mixtures as I see them, then make the necessary minor corrections later in the studio, where the light is favorably balanced and my judgment is, therefore, more accurate.

Open Shade. Often, open shade is the only choice available as a vantage point from which to paint. In spite of the excessively cool tone of the light, it is far better than placing a canvas in full sunlight. Open shade is full of unexpected color temperature changes, particularly when there is snow or light sand as a ground color. The predominant color temperature relationship is cool lights and warm darks, but this can reverse itself back and forth, due to secondary light sources reflecting into the shadow. The optical properties of the particular subject can also cause unpredictable and often frustrating color contradictions. A friend of mine went to Antarctica and nearly gave up painting after attempting to paint the unique light phenomenon that occurs on the shadow side of an iceberg.

Local Phenomena

There are countless factors of geography, terrain, weather, and atmospheric conditions that interact with light to radically alter and even contradict the behavior of natural outdoor light. A classic example is the famous "Mediterranean blue." The waters of this sea take on an incredible azure brilliance under direct sunlight. Trying to match this color has frustrated generations of painters. The cause of this remarkable color is probably the exceptional clarity of the waters caused by the very low level of microscopic marine life in the sea. The first time I attempted to paint the Mediterranean, I came away with a new appreciation of the Impressionists.

Another example is the relative difference in atmosphere between the European Alps and the American Rockies. The air is so clear in the Rockies, particularly in Colorado, that often distant ranges appear as close as near mountains. The Alps, on the other hand, oblige the painter with a heavier atmosphere, with consequently more pronounced value and color temperature changes that easily denote distances.

The list is endless. Fog, mist, dew, frost, rain, snow, the seasons, terrain, even the mood of the painter, are all variables for which there are no possible guiding rules beyond the principle of self-reliance: when all else fails, paint what you see.

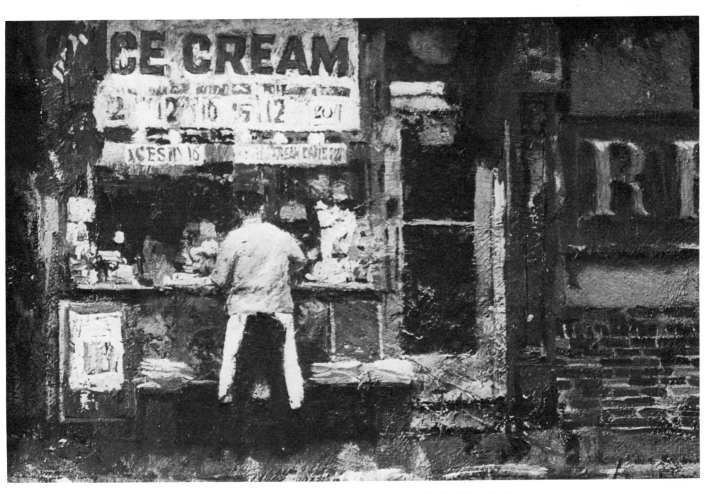

Ice Cream Shop. Oil on panel, 8″ x12″ (203mm x 305mm). I included this little sketch of a west side Manhattan store front as a comment about landscape painting. Many people have never seen a real "landscape." I speak here of a landscape in the traditional sense—forests, pastures, mountains, and all the rest. I never saw a mountain until I was 18 years old. When I lived in Manhattan, I knew many people who had never been east of the Hudson River. To these people the street they live or work on is the only landscape they know. I also know country people who have never left the farm they were born on. So this is as much of a landscape as any pastoral ever painted. The sketch itself is one of many quick studies done for the sole purpose of capturing an impression of one sort or another. In all cases I use direct painting for these sketches and they rarely consume more than half an hour. Often, because of their small size, I could wander around New York and do three or four in a day. Many of these sketches served as the nucleus of a larger canvas. Taken together, all the small studies amounted to a rich storehouse of visual information from which I still draw upon in my work. I can remember nearly every picture I have ever painted, including the failures—especially the failures.

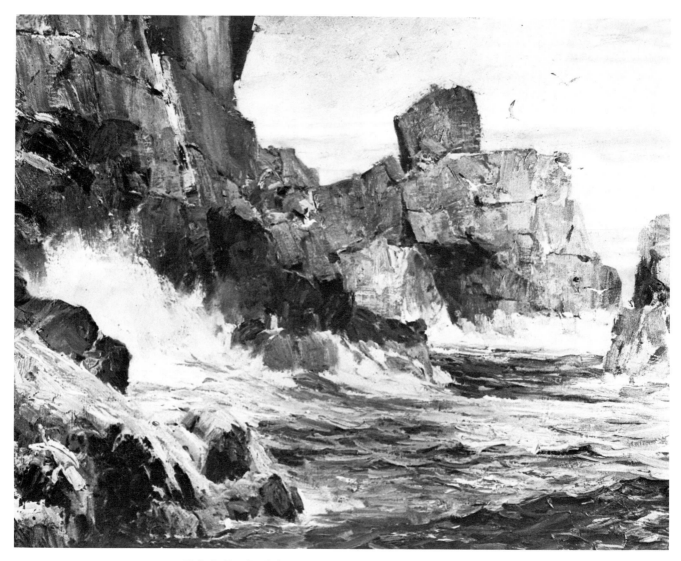

Pulpit Rock. Oil on canvas, 24″ x 32″ (610mm x 813mm). This may be a familiar sight for many painters in New England. It is one of the many outstanding rock formations on Monhegan Island, a small island in the North Atlantic about 12 miles south of Port Clyde, Maine. The island has attracted artists for generations. It is amusing to walk around the island and note the number of semicircles of paint on the rocks where artists have used them for a palette. Most "marine" paintings contain only three elements—sky, water, and land—although incidentals are often added, such as a lighthouse (a perennial favorite), fishermen, or ships. To me all of these extras are just so much flotsam. The sea, the natural formations of a coastline, and the elements are more than enough, plus of course, the ever-present gulls and other shore birds. The essence of the sea is movement and the movement of waves must be studied in terms of characteristic patterns; otherwise the result will appear to be frozen in motion like a high speed photograph. Some wave patterns are simple, while others seem hopelessly complex; nevertheless, all running seas have a rhythm that can be understood with patient observation. Except for the factor of movement, painting a "seascape" is no different than a landscape. In this case, I began with an opaque and transparent block-in. The canvas was heavily painted with extensive palette knife painting throughout the canvas, particularly in the rocks. The effect of movement in the waves and breakers is accentuated by impasto brush and knife painting as well as careful attention to a variety of edges.

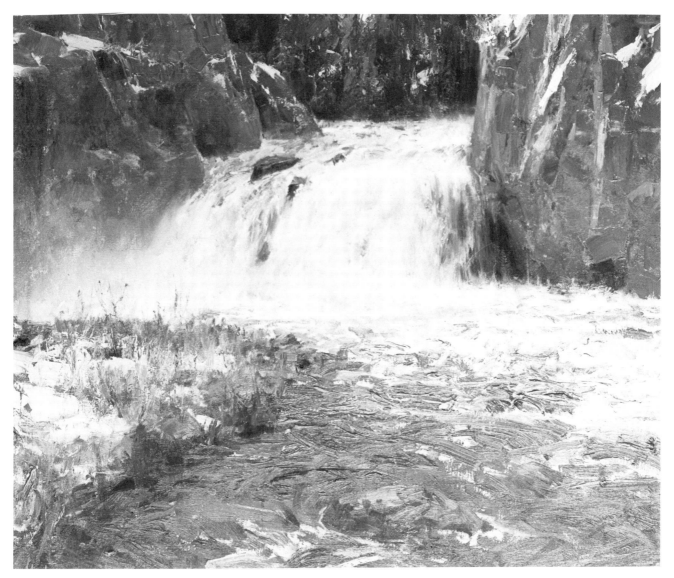

Firehole River. Oil on canvas, 30″ x 36″ (762mm x 914mm). The Firehole River, which winds through the northwestern corner of Wyoming, is certainly not one of the world's largest cataracts. But all of the Niagara Falls in the world could not have been more striking than the effect of sunlight on this rushing water. The river was swollen by a spring thaw and the violence of the white river was greatly increased by the narrow gap formed by the two huge rock formations on the extreme left and right. My vantage point appears a bit precarious; however, I was high and dry on the river bank about 30 feet from the bottom edge of the foreground. I chose a large canvas in order to convey the massive effect of the falls and rock formations. In spite of its size, the painting required only a normal amount of painting time because the scene involves only a few simple masses and a minimum of detail. The sun was high in the sky at an angle slightly in front and to the left of my canvas so I was painting slightly into the sun. I began with a quick block-in similar to the example in Demonstration 1. With this completed, I immediately placed all of the light areas in the waterfall and rapids on the right with heavy impasto mixtures of cadmium yellow and white. Into this heavy paint I applied the darker halftones in the water, finishing right down to the foreground. I then painted the small area of snow and low brush in the left foreground. Finally, the rock formations in the upper half of the canvas were applied entirely with palette knife painting.

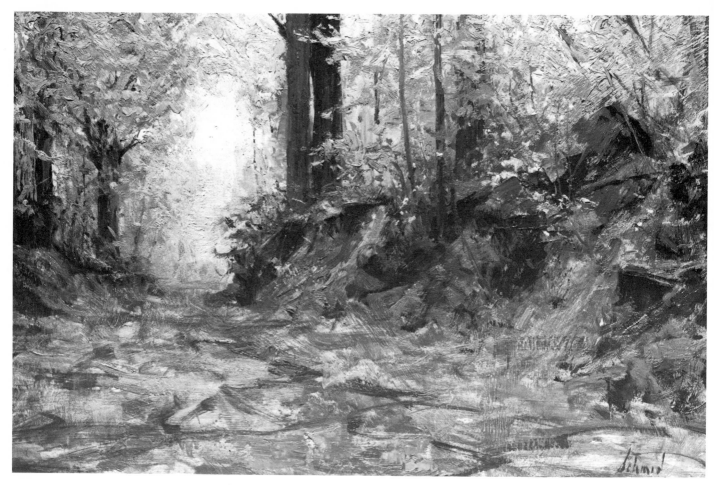

Wood Road. Oil on panel, 12″ x 18″ (305mm x 457mm).

DEMONSTRATIONS

The paintings and demonstrations that follow illustrate a variety of familiar landscape subjects as well as the problems involved in resolving each into a coherent, artistic statement. In some cases I will deal with a variety of ways to render similar effects. Some demonstrations, therefore, will begin with similar block-in techniques and proceed into different subjects or finishing methods.

The demonstrations are grouped according to the way in which each painting is started. The start of a painting is called the block-in. The dictionary defines a block-in as "a sketch or outline done roughly and generally without detail." I would redefine the block-in technique I use as "a sketch or outline accurately done, with only necessary detail."

I am concerned with accuracy and detail in the block-in stage because I believe that a sketch can be superbly loose and free—yet entirely accurate at the same time. To me, there is no valid reason why brush-strokes cannot be spontaneous and lively, and still be the right length, shape, and color in every stage of painting—particularly in the beginning. The notion that it is better to start a painting right than to start it almost right seems simple. It is hard to argue against the idea that an accurate block-in is more likely to yield a successful painting than a vague sketch. However, perhaps because this idea is so self-evident, it is easily taken for granted.

I must emphasize the importance of the block-in because the way in which a painting is started determines the entire course of the work. This is particularly true in landscape painting where time is a major factor. Reasonable speed and accuracy at the beginning can make the difference between a successful study and a wasted effort.

The classification of landscapes I use here is also a matter of convenience. For the sake of clarity, I must use a system of categories based upon the combination of factors within a landscape and the consequent block-in they suggest. A simple example would be the impressionistic block-in—where a landscape contains a myriad of small shapes of different colors illuminated by diffused or direct sunlight. Such a situation practically demands the kind of block-in that will lead into a broken color rendering. Similarly, a landscape with only a few large, well-defined areas and strong light, suggests a block-in that, if it is accurate, will be a finished sketch in itself. These examples are conclusions I would reach as the result of what I see in the landscape. Another artist would probably see something else and paint quite differently and the result would be just as good or better.

After selecting a subject and a good vantage point for working, a number of things converge that determine my canvas size and procedure. These are: (1) the available working time, (2) the quality of the light, and (3) the nature and complexity of the subject. These factors are interrelated and usually depend upon the available working time. To put it another way, after deciding on what I want to do, how much time do I have to do it? This question naturally applies only to *alla prima* (one session) painting. Time is no problem when it is possible to return to the subject several times until a painting is finished. As I mentioned earlier, when working in the field I prefer to paint in one try or not at all. The freshness and spontaneity of a sketch diminish with each working session. Moreover, Mother Nature is rarely accommodating enough to present exactly the same conditions from one day to another. Also, in a

purely subjective sense, an artist's perception is not precisely the same from one day to another.

Working time is determined mainly by stability and duration of the light. My personal judgment is that if there is less than an hour and a half of stable conditions I will not even start a sketch. Other factors that affect working time in the landscape itself are physical changes, which generally occur at the beginning and end of the day. Early morning fog, mist, dew, or frost are likely to undergo rapid changes during the time it takes to finish a sketch. In the late afternoon and evening, haze and rapid variations in cloud structure often develop, especially in summer.

There is no foolproof way to handle these changes except to anticipate them and work as fast as possible. Many effects of light and atmosphere are so brief that only memory, photography, or a thumbnail color sketch will produce a worthwhile result. Other changes such as the tides, wave patterns, midday cloud patterns, light angles, and wind direction generally happen more slowly and present no real problem.

Aside from the natural events already mentioned—rain, snow, extreme temperatures—there are no serious natural conditions to contend with unless a painting is attempted in lion country or within a combat zone.

During one of my painting trips in the U.S. Southwest, I was allowed to paint within private Navajo areas by courteously securing permission just as I would on anyone's private property. Once on an isolated reservation (not Navajo), I was ordered away at gunpoint. A more mundane but common situation is the accumulation of spectators, especially while painting on a city street. People are fascinated by an artist at work. I have never minded onlookers, in fact I take their curiosity as a compliment as long as I am free to paint and not answer questions. Local police take a dim view of street painting because it attracts crowds, which is understandable. In other places, I have been ordered away without reason or required to secure a sketching permit. (In Central Park, Manhattan, I never bothered to get the permit.) The best time to paint in any big city is early on Sunday morning when the streets are nearly deserted and work can be done in privacy.

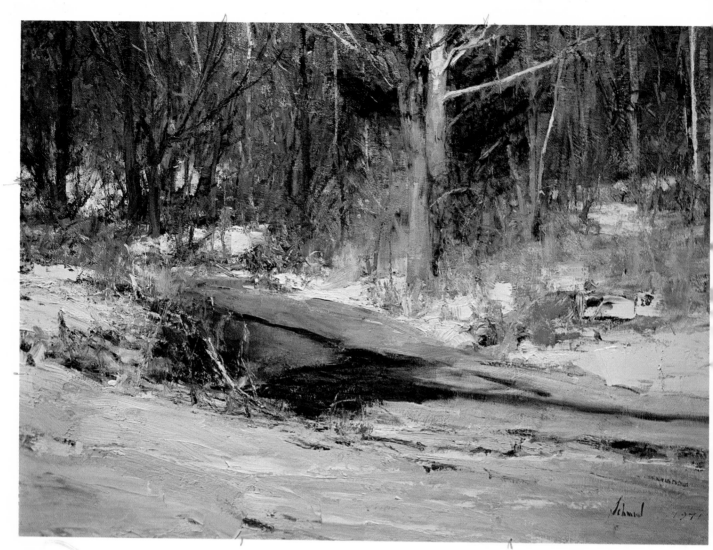

Sycamore. Oil on canvas, 24″ x 36″ (610mm x 914mm). This painting began as a standard block-in. The subject—snow and trees—is much the same as the demonstration, but the similarity ends with the block-in. Here I am working with direct sunlight. It slides across the snow bank in the foreground and slams into the middleground and the two central trees. This powerful focal point, formed by the high contrast in the snow and trees, is balanced by a secondary focal area formed by the convergence of the dark pool with the foreground snow and sunlit branches and reeds in the middle foreground. In contrast to the demonstration painting, very little of the transparent block-in remains visible in the finished picture. The white lead ground of the canvas was not brilliant enough to match the intensity of the sunlight striking the snow. After the block-in, I immediately worked into these bright areas with a heavy impasto of white and cadmium yellow. I used a combination of heavy palette knife strokes and brushwork. The knife painting is conspicuous on the right. Next, I placed the darks in the stream and behind the center trees with ultramarine blue and burnt sienna, keeping this mixture as thin as possible. With the lightest lights and darkest darks established, the remaining halftones are relatively easy to judge, and during the finishing process, everything else can be related to these areas.

1

Standard
Block-in

Everything about the painting in this first demonstration is typical of the procedure I use most often in working from life. The other block-in techniques are variations or modifications of this approach. (The differences, however slight, are important.)

The subject here is of average complexity, the light is dependably stable, and the overall harmony is a cool, gray tonality marked by temperature changes rather than conspicious color changes. There is more than enough painting time and nothing in the landscape is apt to change very much, so I can start a large canvas—22″x 28″ (559mm x 711mm)—with confidence because everything is working in my favor.

The actual working method is also typical of all my outdoor work. I set up my easel about 30 or 40 feet back from the point at which the foreground of the painting will begin (in other words, the bottom of the canvas). Unless the foreground is the focal point, I rarely start closer than 30 feet because of the distortion involved. Beginning painters often attempt to paint everything from the toes of their shoes to the sky directly overhead. The effect of this 180° vertical vision is the same unsettling distortion produced by a "fisheye" lens. Our eyes don't work that way.

After arranging all my paints and brushes, as pictured on p. 23, I begin the block-in by placing the most obvious things first. The reason for this is logical—the most obvious elements, such as the lightest lights, the darkest darks, the strong, clear-cut areas, are the easy parts to paint. They are easy to see and judge in terms of value, drawing, edges, and color, so there is a good chance that they will be correctly painted. It follows naturally that as more correctly painted areas accumulate on the canvas, the easier the rest will become.

I can judge subtle and ambiguous values and colors more easily when they are placed against areas that are accurate. If something seems a bit disturbing when applied next to a correct color, it is a simple matter to decide what is wrong with it.

There is a tendency among some painters to do just the opposite. They withhold the easy, obvious parts until the end of the painting session (which is rarely reached) in the mistaken idea that the hard parts, i.e., the subtle halftones and gray mixtures, must be conquered first because the easy parts can always be placed later. To me, this kind of thinking is an example of the triumph of hope over brains. I cannot see any reasonable argument against the earliest possible placement of accurately painted areas, particularly in outdoor work where time is so precious.

When the block-in seems to be carried to a point where all the major areas are indicated, I give my palette a good cleaning and generally check over my brushes and paint to make sure everything is ready for the finishing work. Once I begin to lay in the opaque paint, a stride develops that I hate to interrupt by running out of paint or clean rags. The break between the block-in and final work is also a good time to back off and take a long look at the subject and the painting to decide how much actual finish painting is necessary. In many cases, as in this one, a large percentage of the block-in will remain visible in the final stage.

Despite the size, this painting was completed in about three and one-half hours. The care taken during the block-in certainly shaved off an hour of corrective reworking.

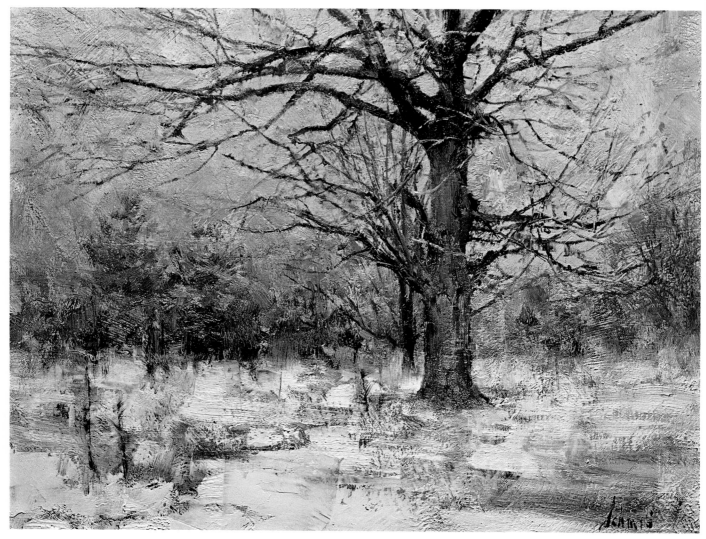

Winter Maple. Oil on canvas, 12″ x 16″ (305mm x 406mm). This sketch is typical of the type of small, quick study from life that can either stand alone as a finished work or serve as the nucleus for a larger painting. The foreground and background are carefully subdued so they will not compete with the very delicate and complex drawing in the maple tree. The sketch was started on a January afternoon and my painting time was limited. Starting a large canvas was out of the question, so I settled for a canvas size that could easily be painted in one an hour and a half. Because of the time element, I also decided to confine my attention to a tree study. Although this is a full-color painting, the overall effect is one of cool, gray harmony. After a quick block-in, I painted all the areas behind the tree, including the sky. I cut into the area of the tree slightly with the background in order to have wet paint to work into. The dark accents in the tree are all mixtures of burnt sienna and black. The halftones are all variations of cobalt blue, yellow ochre, terra rosa, and white. Most of the tree is rendered with small filbert brushes. The dark accents and more delicate areas are a combination of palette knife painting and careful brushwork with small round sables. The foreground is finished with a few broad brushstrokes softened with a palette knife.

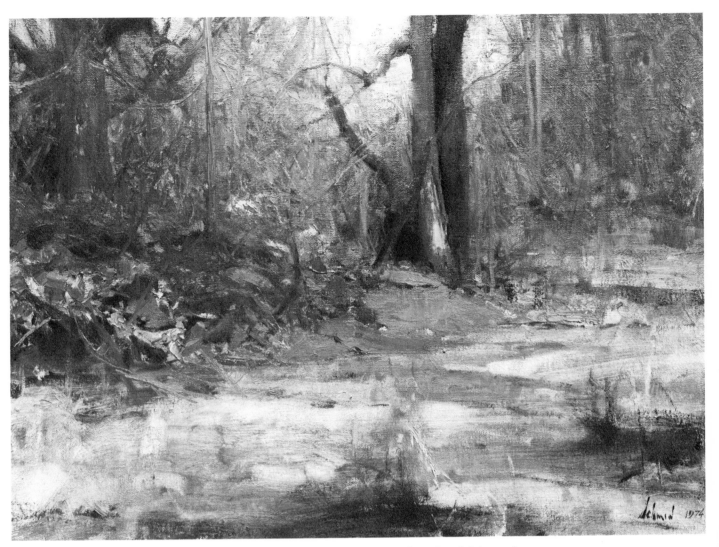

Marble Creek. Oil on canvas, 18″ x 24″ (457mm x 610mm). The title of this work may seem confusing because no creek is apparent. The foreground was once a stream, although in late autumn the stream is usually dry. However, this is not really important since titles are silly things to begin with and the creek is not the subject anyway. The real statement is the overall mood of a northern temperate forest—or at least one intimate glance at it when the snow is holding back. Amidst the maze of color and form, the tree complex in the center serves as a focal point. The visual problem is virtually every subject similar to this is to simplify countless elements into a pictorial statement that the eye can take in at a single glance. The normal human eye does this naturally because it only focuses on one thing at a time. Peripheral vision is expressed in painting as areas of lesser contrast, sharpness, brilliance, and complexity. Everything, therefore, is subordinate to the point on the canvas where the two strong trees in the center converge. In every respect, this work followed the course of the painting in this demonstration.

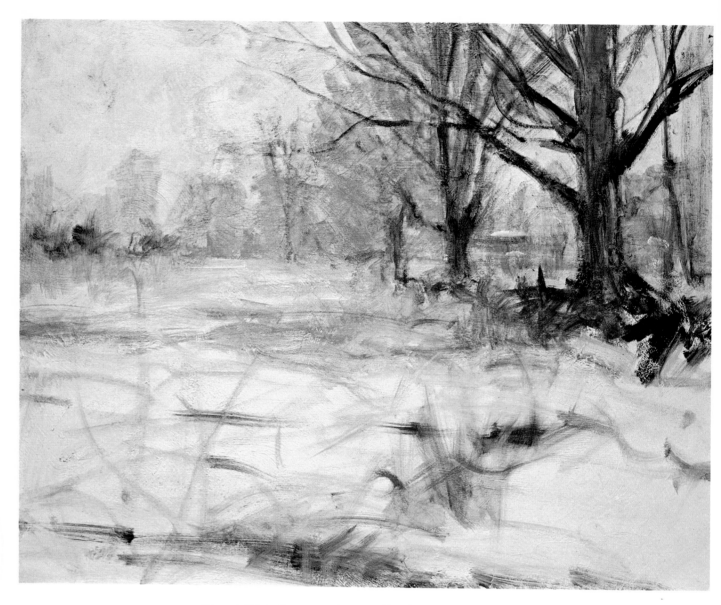

Step 1. This first step is actually the finished stage of the block-in. Except for a few isolated brushstrokes, it is painted entirely with transparent mixtures. At this point the painting is confined to only five distinct values. The white lead ground of the canvas serves as the lightest light. This constitutes the majority of the foreground areas and the sky. The darkest dark, on the right at the base of the nearest maple tree and on the underside of its lower branches, is a mixture of ivory black and burnt sienna.

The dark halftones in the trunks and branches of the trees are roughly the same mixture, with burnt sienna slightly predominating. The very warm dark at the right is pure transparent burnt sienna. There are two principle middle tones. The first is a cool mixture of cobalt blue and yellow ochre. This value completes the remaining tones in the distant treeline. The other middle tone is warmer—yellow ochre with slight additions of cobalt blue and viridian. The light halftone is only apparent in the sky and middleground. The entire block-in is rendered with medium and large bristle brushes. The elapsed painting time is about 20 minutes.

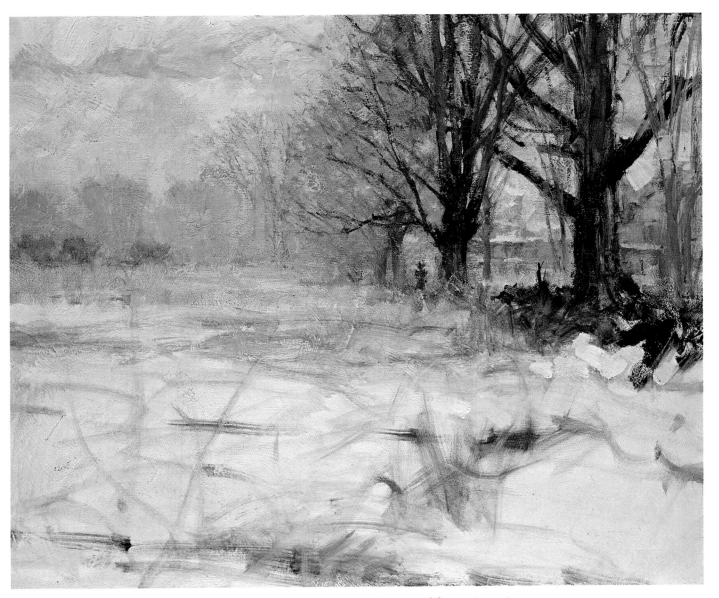

Step 2. At this point, with a solid start to work with, I could continue in any area. However, a lot of time and repainting is saved by working in progressive stages, beginning with the most distant areas and ending with the foreground. This is a logical procedure because the composition, like that of most landscapes, is a problem of multi-layered elements. Edges become important from this point on and some key edges cannot be achieved unless it is possible to work into or over a finished layer of fresh, wet paint. Therefore, the sky is finished first, using cobalt blue, yellow ochre, and white. The light areas in the clouds are applied as a heavy impasto with alternating strokes of the palette knife and the brush. The areas to be overpainted by trees are thinly painted to avoid excess accumulation of paint. Using the same colors, with the addition of touches of terra rosa and burnt sienna, the distant trees on the left are brushed on with large filberts. Continuing to the right, slightly broken color is applied in the center to indicate tree branches in the middleground. This also acts as preparatory brushwork, serving as a partial underpainting for the more accurately drawn trees on the right. The background on the right is finished with the suggestion of architecture.

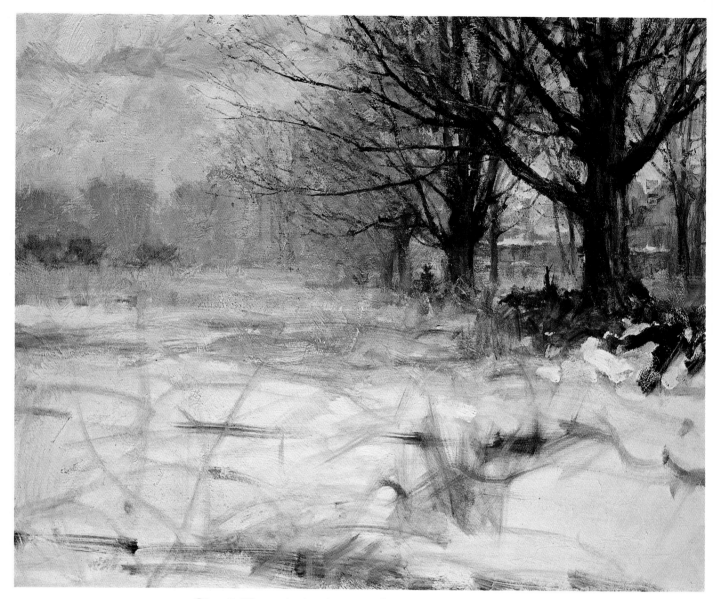

Step 3. The painting is carried to near completion with the development of the large maple trees on the right. This is the point where I slow down and pay more careful attention to the complex drawing in these trees. Together, they form the principal focal point. The painting as a whole, besides being a study in the atmosphere and mood of a particular winter day, is also a foil or setting for what amounts to a portrait of two old and powerful trees. The formation of the branches of these sugar maples is a beautiful record of their fortunes over more than a century. In painting the trees I progress in the same way the trees grow; upward and outward. Using mixtures of burnt sienna and cobalt blue with ivory black, yellow ochre, and white, the mass of the trunks and main branches are painted with medium filbert brushes and a palette knife. Portions of the lower trunk of the nearest tree remain untouched from Step 1. As I work upward into the smaller branches, I switch to small, long bristle filberts and small, round sable brushes. Some of the most delicate work is done with a small amount of paint picked up on the edge of a palette knife and carefully touched, edge-on, to the canvas.

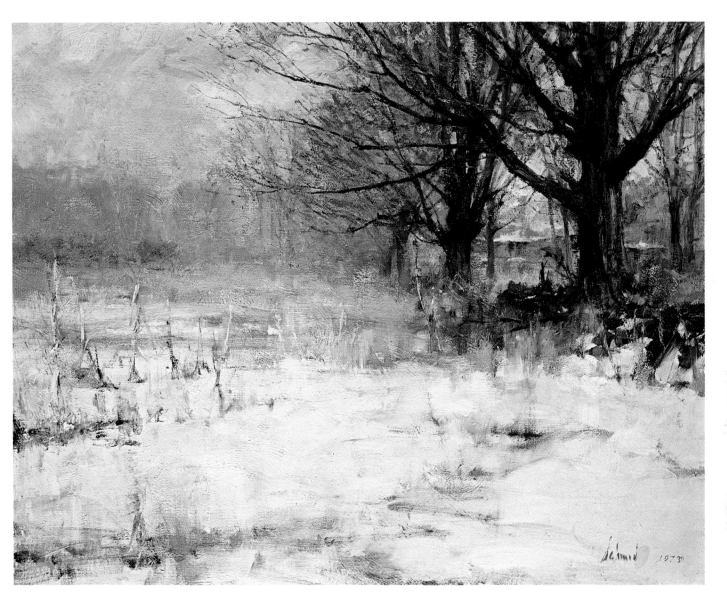

Winter Landscape. Oil on canvas, 22″ x 28″ (559mm x 711mm). The final stage of the painting involves only minimal working in the foreground. This is brought to a point where things are identified—light, snow, cornstalks, clumps of grass, etc. The texture of the paint is interesting but not overworked to the extent that it might compete with the trees. The snow areas are all mixtures of white, cobalt blue, and small touches of terra rosa and yellow ochre first applied with large filbert brushes. The brushwork is then alternately smoothed and scraped with a palette knife. Finally, some drybrush is applied, partially obscuring the transparent darks originally placed in the block-in. The soft areas of grass are mostly warm mixtures of cadmium yellow, yellow ochre, and terra rosa, applied in vertical drybrush strokes. Contrasting with the grass, the cornstalks on the left and the rocks and brush on the right are strongly painted with a palette knife and medium flat bristles. Later, after bringing the painting to the studio, I soften some of the knife painting with light drybrushing throughout the entire foreground, middleground, and distance. This final "bringing together" has the effect of slightly increasing the emphasis on the main focal point.

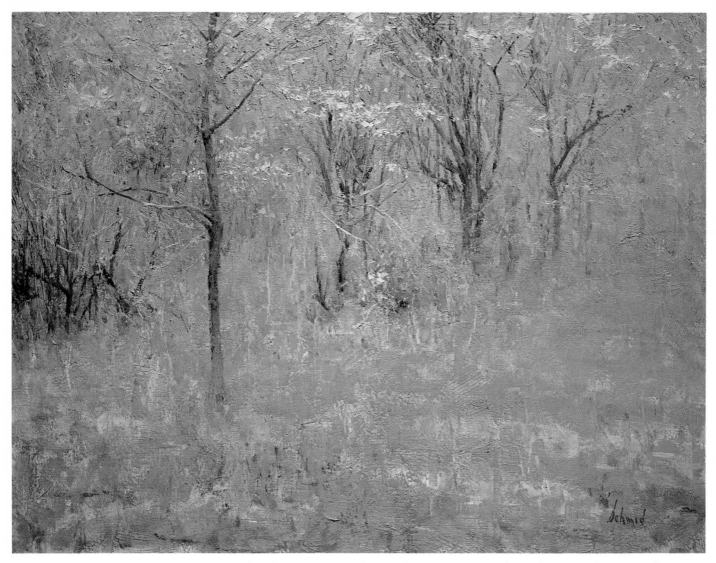

Dogwood. Oil on canvas, 18″ x 24″ (457mm x 610mm). In the normal course of my work I am usually satisfied with my results. I don't mean that everything is a masterpiece, but generally I come reasonably close to what I set out to do. Every so often, though, a painting seems to happen almost as if it were painting itself for my pleasure. This is one of those rare sketches. It is an example of pure impressionism tempered by just the right amount of careful drawing. I came across this small stand of young dogwood trees during a sketching trip near the foothills of the Great Smoky Mountains in North Carolina. To set the color key, I began with a rich, transparent wash of viridian and cadmium yellow. I then quickly covered the entire canvas, using a turpentine-soaked rag to spread the tone evenly. While this tone was still wet, I varied it with strokes of cobalt violet in the upper half of the canvas, and cadmium yellow in the lower half. This was allowed to dry for a few minutes. The next step was to apply broken color in the entire upper half of the canvas in preparation for overpainting the dogwoods. (This broken color is still undisturbed in the finished painting on the extreme right.) The trees were placed with particular care to their edges, so that they would blend into the painting as a whole. Only the trunk and lower branches of the tree in the left foreground are rendered in detail. I brought the canvas to completion with a variegated foreground of viridian, cadmium yellow, and cadmium red.

Long before the French Impressionists made their appearance in the later half of the last century, many artists before them—Velázquez, Rembrandt, and Turner, to name a few—were already using the equivalent of Impressionism in their work. The idea of broken color was nothing new. Impressionism has been a standard tool for artists ever since painting ceased to be what amounted to colored drawings and came into its own.

The French Impressionists, as we know, did far more than use this technique as a tool. For them it was an end in itself. In spite of the fact that they flourished for a mere 20 years, their efforts launched a revolution in art that is still in progress. They were almost entirely concerned with light and color, showing little interest in the physical characteristics of what they were painting. Happily for all of us, in keeping their focus on such a narrow but vital property of nature, they resolved most of the important problems of *plein-air* painting. The inroads they made in painting developed into highly sophisticated techniques, and today, Impressionism can be a standard tool in any painter's repertoire of techniques.

This demonstration shows how the subject, with its particular combination of light, atmosphere, and landscape character, suggested an impressionistic approach in the form of a broken color foundation. This does not necessarily result in a broken color finish, but it does lay the groundwork for a strong effect of color and light in the finished work. At the same time, it allows for emphasis on the other pictorial elements—drawing, edges, and value.

This is a small sketch, only 12″ x 18″ (305mm x 457mm). The size is important because the available painting time is fairly brief—not more than two hours. It is an early spring morning with a high overcast, providing beautifully diffused sunlight coming from behind me and slightly to my right. There is a light mist that is typical on spring mornings. I know from experience that because of the absence of wind and direct sunlight, the mist will hold steady long enough for a painting. Even if it does not hold, it is only critical in the middle and far distance, which I will finish first anyway.

In the center there is the overgrown course of an old woods road, providing a soft perspective line into the picture. Flanking the road on the left is the principle focal point: a young white birch with a white rock at its base.

In the same area there is a rich assortment of trees and brush, a few dark cedars, a fine black birch in the middle foreground, and swamp maples in the distance. The right is not as pronounced. There is only a hint of a small cedar and a white pine with maple trees and brush more or less lost in the mist.

So the problem is to paint this maze of brushwood, foliage, and branches, all softly lit by a misty spring sun. The atmosphere produces an overall warm tonality, so my first task is to quickly lay in a lot of color to establish not only the color key but also an underpainting that will show through between the finish brushstrokes. This first paint layer is composed of both opaque and transparent washes. From this point I develop the background and faintly indicate some of the principal trees and dark values on the left. Now the most important things are done. The remaining work is really just a matter of building on the paint already applied. This is often the hardest part because precision drawing is necessary in key areas that will not destroy my initial efforts. Attracting too much at-

Demonstration
2
Impressionistic Block-in

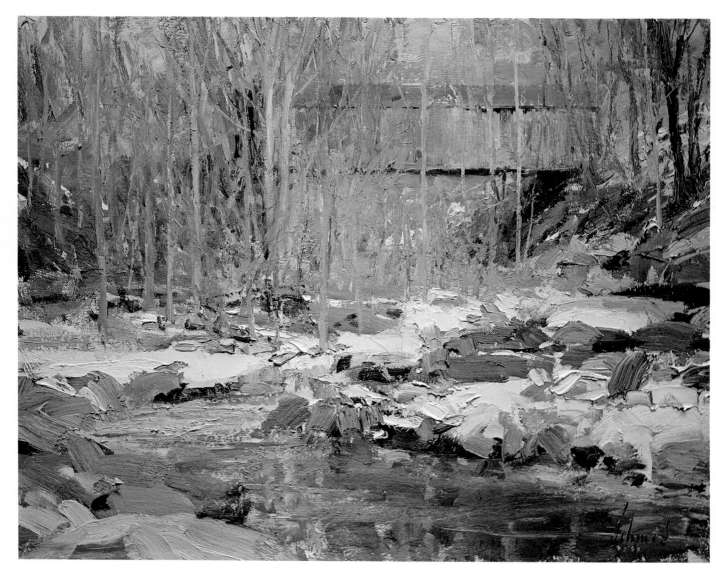

Bull's Bridge. Oil on canvas, 16″ x 12″ (406mm x 305mm). In principle, I am against the idea of painting covered bridges, mainly because as subject matter they have been worked to death. Together with lobster boats and candy-striped lighthouses, they are among the most enduring clichés in painting. I have resisted painting them until recently, but I finally succumbed—so I have two covered bridges in this book. I can live with this because neither painting is rendered in the tried and true "covered bridge tradition." In this sketch, the bridge is only an incidental shape in the middle distance. The painting is actually a study in light and an exercise in palette knife painting. The bridge could be painted out and the painting would remain undiminished. The situation here is a brilliant, cold February morning. The subject is a maze of trees, rocks, snow, and water with reflections. Given all this, plus the winter cold and brief painting time, an impressionistic approach was the only feasibility. The choice of palette knife work in the snow and rocks is natural because of the angularity and smoothness they present. Another factor was the stiffness of the paint due to the cold. This caused me to use palette knife and heavy impasto brushwork in all areas. The snow is a mixture of white with a touch of cadmium yellow and the addition of cobalt blue where it goes into shadow on the right. Virtually all remaining mixtures except dark accents are cobalt blue, yellow ochre, terra rosa, and white, always with one or another predominating, such as terra rosa in the upper left.

tention to detail would lose sight of the larger statement—the prevailing mood of a particular spring morning. In the final few minutes I work with a palette knife to achieve a variety of textural effects.

After this I spend a few moments comparing my sketch to the scene before me. After about two hours of work, the mist begins to lift and the light has already changed its angle. With a few mental notes made during the course of the painting, I return to the studio and make a few very minor corrections. This can be a crucial time. It is not a sound practice to repaint extensively in the studio a painting done outside. I have ruined more than one good sketch this way. It is best not to even look at the sketch for several days. Usually it turns out that nothing done in the studio can possibly add to the essential spontaneity of a sketch from life.

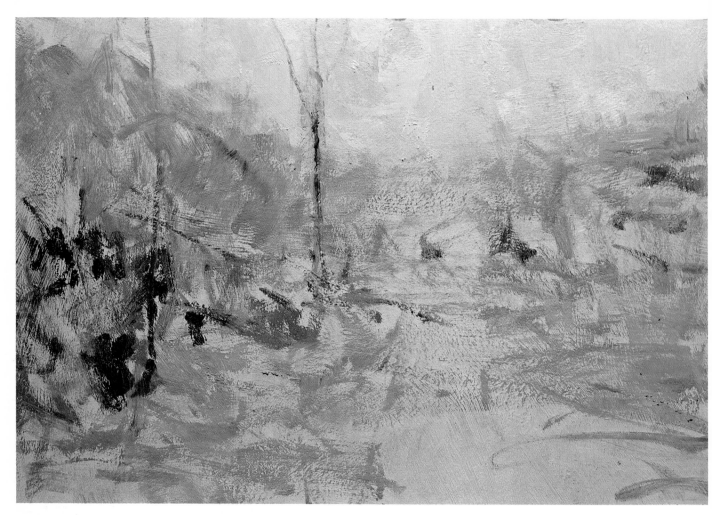

Step 1. In this block-in, as in most impressionistic beginnings, I generally use only one brush—a medium size flat or filbert. It does not matter very much what is used—sometimes I use a rag or a palette knife. Most importantly, I quickly lay in a lot of color without being reckless. On this sketch I will not even stop to tone the panel. The white lead ground is visible in every area at this stage. Nearly all the paint in the lower half of the picture is transparent. The mixtures in the green area are predominantly viridian and cadmium yellow. The warmer tones in the same area are yellow ochre straight from the tube with occasional touches of cadmium yellow and cadmium scarlet. On the left I use pure terra rosa applied as a scumble, *i.e.,* using the paint in the same consistency as it comes from the tube and scrubbing it into the surface with a large brush. This leaves a thin layer of paint that does not dry flat as quickly as mixtures diluted with turpentine do. This may seem a minor point, but there is a particular reason why I use a variety of surface applications. In this case, the darks on the left will be shadow areas and it is important that they remain transparent. The initial stage of this block-in is completed with the application of opaque mixtures of cobalt blue, yellow ochre, and cadmium yellow in the entire sky area. This is a combination of palette knife and brush work. As a final touch, I lightly paint a vertical line to the left of center, establishing the relative scale of all the trees in the painting.

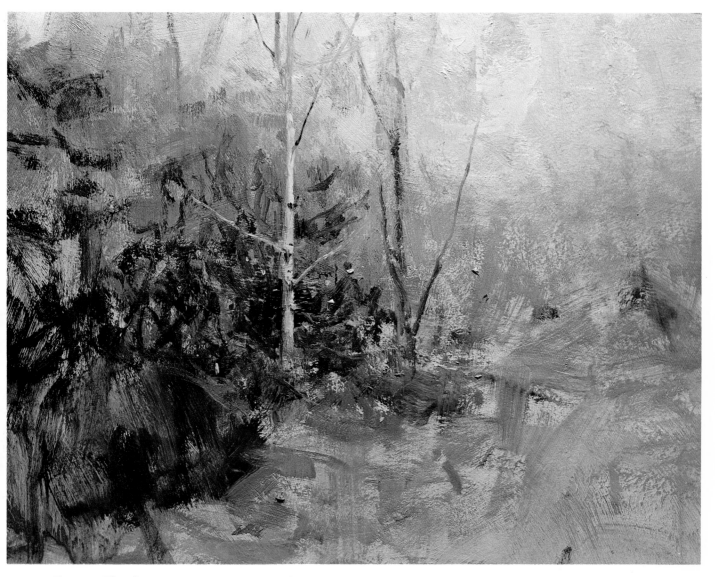

Step 2. The first step may appear to be an indiscriminate or random assortment of color, but looking at this second step, the first begins to make sense. Each step, besides resulting in some amount of finished painting, also lays the groundwork for subsequent painting. Going into this step I already have before me: (1) a finished rendering of the sky, (2) an overall color key, (3) the lightest and darkest values, and (4) a fresh underpainting. This detail of the left and center of the painting is the area of the principle focal point as well as where difficult and important drawing is first resolved. The white birch is brushed on over a thin layer of burnt sienna and black. I continue to work back and forth between the birch and the background in order to effect the modeling and edges in the main trunk and in the three main shoots in the center tree (the swamp maple in Step 1). More values and colors are added in the right and center foreground and on the left. The darks on the left are transparent washes using burnt sienna and ultramarine blue. The mixtures and application in the foreground are substantially the same as Step 1. It should be noticed here that the sky has hardly been altered.

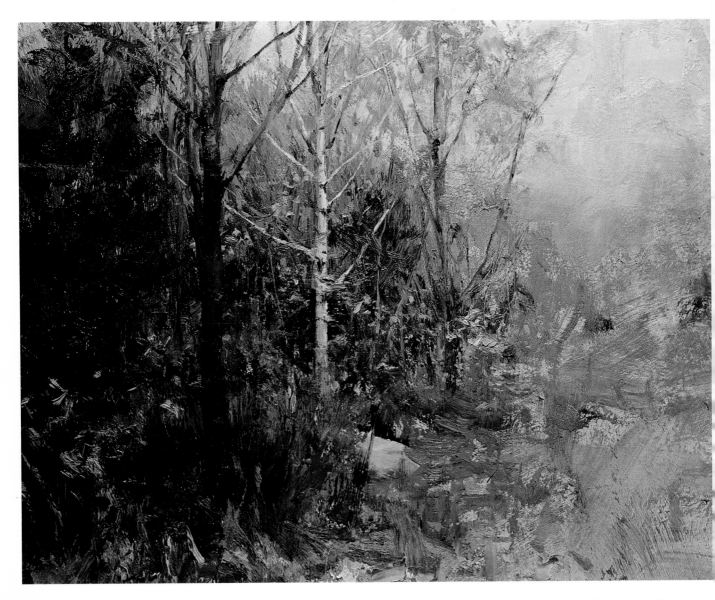

Step 3. In this detail, the same area as shown in Step 2, the work involved will consume 90 per cent of the painting time. It is an area of intricately layered trees and underbrush. There are several bad ways to handle this. One way is to paint each leaf, branch, and blade of grass separately. Another way, and probably the most prevalent, is to adopt a stylistic brush technique and paint everything the same. Both of these extremes are insults to nature. I feel that the forms in nature are unique and their visual characteristics must be understood and rendered accordingly. Far from being a burden, this is one of the delights of landscape painting. I can use the full repertoire of techniques from thin washes in the added darks on the extreme left to heavy, impasto palette knife strokes, as in the rendering of the white rock at the base of the white birch. Nearly all the paint mixtures in this step are the same as in Steps 1 and 2. The entire concern here is *how* the paint is applied. The black birch on the left is heavily painted with medium filberts and small round sables. The dark cedar on the extreme left is finished with a large filbert. Small impasto strokes are applied throughout where clumps of leaves stand out prominently—again they are painted in characteristic patterns, and not as individually drawn leaves.

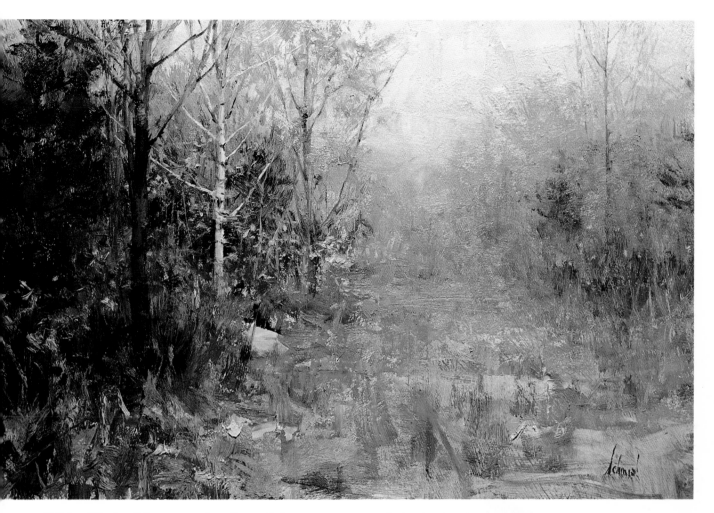

White Birch. Oil on panel, 12″ x 18″ (305mm x 457mm). In the final state, the center foreground and the low trees and brushwood on the right will be relatively simple compared to the complex of growth on the left. This does not mean that the center and right are merely incidental, that any less care can be taken in painting. In fact, it is very easy to scuttle a painting at this stage. It is an old axiom in painting that it requires two people to paint a picture: a painter to do the painting and another (large) person to knock him senseless before he ruins it. There is more truth than humor in this. In practice, an artist is both of these people; he must be his own ruthless critic. The inner voice that yells "stop" must maintain the insight that led to the painting in the first place. To put it personally, when I have said what I wanted to say the way I wanted to say it, no amount of additional dabbling can improve upon it. Both the foreground and center right are a continuation of the same color mixtures described in Step 1, but careful attention to brushing, knifework, and edges now comes into play. An interesting area is in the lower right behind the signature. A mixture of viridian and cadmium yellow is brushed on in the same way as the surrounding green area was brushed on. I then wipe the area with a turpentine-soaked rag. The trees on the right are finished with successive layers of drybrush, then scraped with a palette knife.

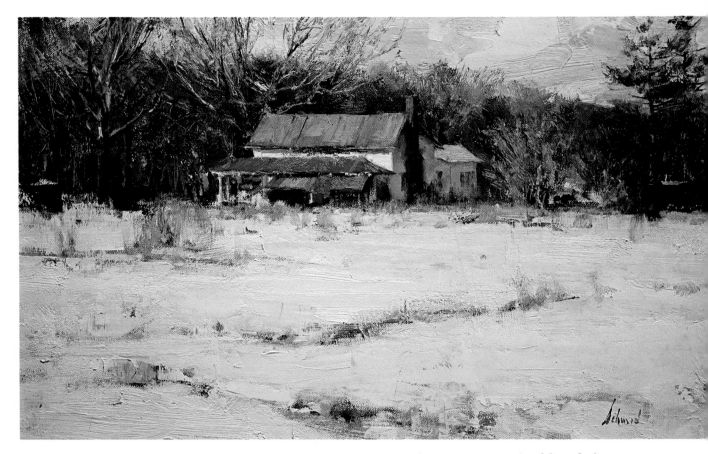

Farmhouse. Oil on canvas, 20″ x 12″ (508mm x 305mm). Although this painting may appear different from the standpoint of surface finish, it nevertheless went through basically the same steps as the painting in the demonstration that follows. The only real difference is the light. Here there is direct sunlight coming in at a low angle from the southwest. (It was late January and I was set up in open shade facing north.) The effect was to shorten the available painting time, so I consequently used a smaller canvas. I was not overly concerned about the time because the more difficult areas—the farmhouse and tree groups—are confined to a small percentage of the total canvas area. Otherwise, this sketch followed almost exactly the same course as the demonstration painting. I began with a preliminary wash of cobalt blue and yellow ochre, one value darker than the snow, over the entire canvas. This was followed by a warm middle tone across the upper half of the canvas as a preparation for painting the low hill in the background. At this point I gave all my attention to the farmhouse. A few careful lines drawn with a small filbert brush established the horizontal and vertical lines of the building. An impasto mixture of cadmium yellow and white was applied with a palette knife on the side of the house receiving the sun. This was followed immediately by the red of the porch roof—terra rosa and cadmium red. That established the enter of interest and I proceeded to paint outward from there to the left and right, finishing as I went from one area to another. The foreground snow was a very simple matter. Too simple, in fact. It was a perfectly flat cornfield. I actually had to prop up some fallen cornstalks in the snow to create a diversion from the unbroken whiteness. The farmer must have thought I was crazy!

Part of the subject for this demonstration is the same covered bridge shown on page 60. In this painting, the bridge itself is a dominant element, but by no means the only one. The main focal point (see Step 4 of this demonstration, p. 71) is just to the right of center where the light section of the trunk of a small tree is strongly contrasted with the black shadow beneath the bridge. This is not a standard, picturesque covered-bridge painting. It is primarily a study in the prevailing light and mood of one of those cold, gray days in March between winter and spring when Mother Nature is not quite sure what season it is.

Some people may regard this as a rather bleak and depressing period, but to me it is a fascinating and dramatic season. The strong basic shapes of nature are powerfully revealed. There is no heavy foliage or snow cover to distract. I like it just as I like the next transition when green begins to appear and the afternoons lengthen with the approach of spring. These feelings about my subject are as much a part of the painting process as the actual application of paint, although once the painting is started my attention is completely absorbed by technical problems.

The bridge just happens to be here. It could be a hamburger stand or the Taj Mahal for all I care. I include it because it presents an opportunity to contrast geometrical lines against the abstract natural shapes of the trees and rocks, etc. The canvas size, 28″ x 22″ (711mm x 559mm), is fairly large for outdoor work, but there is plenty of working time available. There will be no significant change in either the subject or the light for a full day. At this time of year, atmospheric changes are slow and the medium overcast sky, which will be the light on this painting, is likely to prevail for days on end.

This block-in is really a form of *alla prima* painting. Much of the paint is left unaltered, just as it is first applied. In the finished state, the painting tends to expand outward in all directions, from the main focal point just to the right of center. The only actual preliminary work is a warm wash across the center of the canvas and in the area to be occupied by the bridge. The only other preparatory brushstrokes are a few lines in the foreground and middleground to indicate approximate placement of rocks and trees. I use the term "approximate" because I know that when I reach these areas for final painting I will make full use of artistic license and deviate from the true location of objects so they will conform to my judgment about the total composition in the final stage. I often reserve this decision until the very end.

This way of beginning a painting is ideal in this situation because the colors and values are repetitious and simple but the drawing and edges are complex. This method enables me to proceed from one area to another, working out problems of drawing, value, and paint texture, and finishing as I go along without overpowering the focal point that I established in the beginning.

Demonstration
3
Opaque and Transparent Block-in I

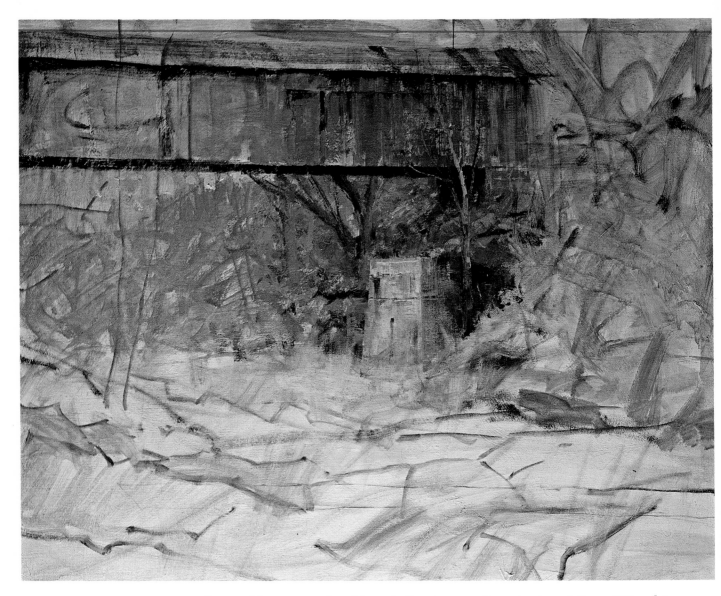

Step 1. The canvas for this painting is a medium-textured linen (Utrecht 21A). I selected one with a rough-textured white lead prime coat because I knew that the rugged nature of the landscape would demand more than the usual amount of drybrush and palette knife painting. The roughness of the prime coat would present both an interesting pattern of accidental effects in the drybrush painting and sufficient "tooth" to support the impasto knifework. Before starting the actual painting, I apply a very thin wash of ivory black and yellow ochre to lower the tone of the canvas one value. This allows me to hold one full value in the light in reserve for final accents and highlights. Before this wash can dry, I apply another, darker, wash of yellow ochre, cobalt blue, and terra rosa in the area of the hillside on the right and carry this same tone into the area occupied by the bridge. I continue with a cooler wash of the same value to complete the hillside that continues behind the bridge and terminates in broken color at the left edge of the canvas. This mixture is terra rosa, cobalt blue, and titanium white in a semi-opaque consistency. A few lines in the foreground to suggest placement of trees and rocks finish the block-in. Beginning at the focal point to the right of center, I begin to paint in detail, more or less finishing one area before moving to the next.

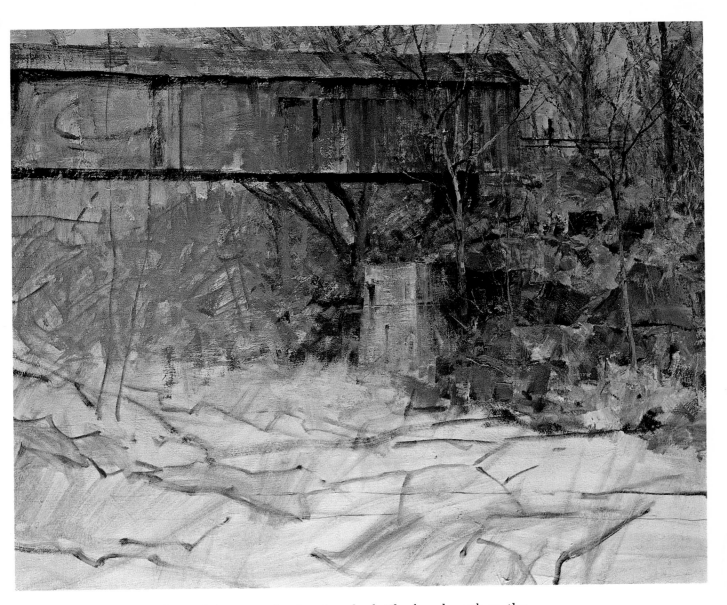

Step 2. The finish work has remained untouched. The brushwork on the bridge and surrounding areas sets the degeee of finish for the rest of the painting. The side boards and roof of the bridge are rendered in semi-transparent tones of burnt sienna, terra rosa, and cobalt blue. The darks beneath the eaves and underside are applied with a palette knife held horizontally and slowly drawn downward. The concrete piling beneath the bridge is almost entirely drybrush painting. The trees are painted with medium and small filberts generously loaded with paint. In this step my efforts are almost entirely on the right side of the canvas. Using mixtures of cobalt blue, yellow ochre, terra rosa, and white, I place the trees in the upper right and top center, using medium filberts and some palette knife painting. The next problem is to work out the alternating pattern of rocks and brush on the hillside. It is necessary to complete these areas first to prepare for the overpainting of the upper branches of the tree in the focal point and the tree emerging from the base of the hillside on the right. Final touches in this step consist of refining edges throughout the area. The most conspicuous is the hard edge where the right edge of the bridge meets the light value of the sky.

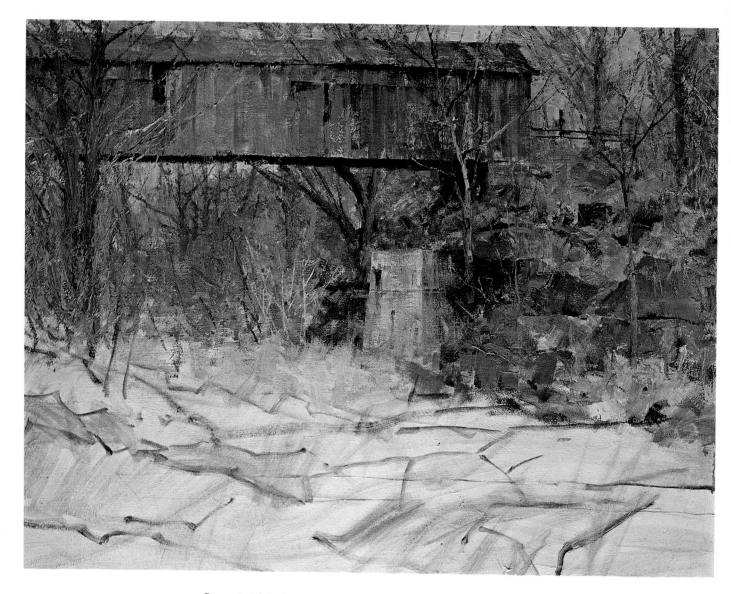

Step 3. This is an interesting stage in the painting from a compositional standpoint. A glance at Step 4 will show why. The unfinished foreground in this step seems to afford some relief from the busy maze of rocks and trees in the upper half of the picture. At this point I could have invented a foreground of snow (which would have been easier to paint than the actual foreground). Although this was tempting, I felt that the busy jumble of natural objects was an important part of what I was after in the first place. So, in this step I just continue working toward the left finishing distant areas first, and progressing forward to complete the bridge and the larger trees on the extreme left. The brushwork and palette knife painting are very much the same as on the right. The main difference is that the painting on the left contains more visible distant areas. The color mixtures tend, on the whole, to contain more cobalt blue and white. There is also more broken-color technique here. The work on the left is less contrasting and specific than on the right—which is the way it should be. Looking back toward the right, I have done no additional work except for placing some small light-colored shrubs beneath the bridge. There will be no changes from this stage except in the foreground.

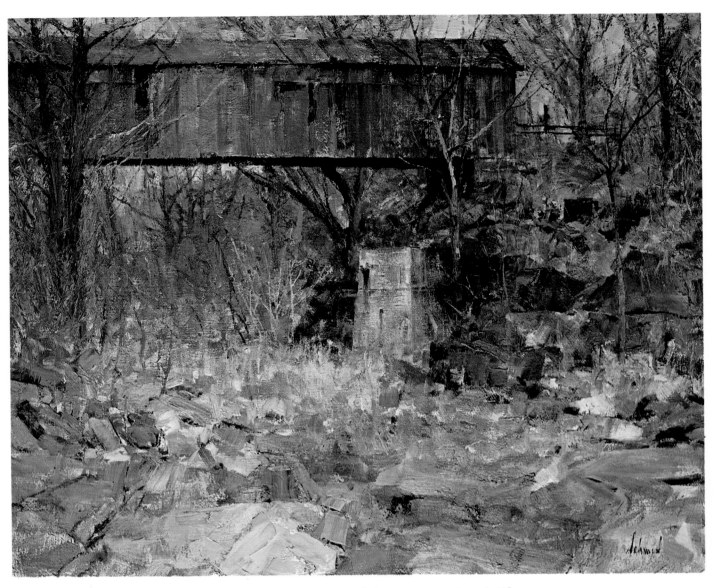

Bridge at South Kent. Oil on canvas, 28″ x 22″ (711mm x 558mm). The foreground painting will not be an easy task. The difficulty is in the fact that everything is an abstract shape compared with the rigid geometry of the bridge and concrete piling. My formula is to render a small percentage of the rocks in a literal fashion. In that way, the more loosely painted shapes will appear meaningful by association. This works because it is the natural way we experience things. The eye will select only one specific point in a landscape and the mind will then construct a plausible assumption about the less distinct information supplied by peripheral vision. For the more distinct shapes, mostly in the left foreground, I use strong palette knife and impasto brush work. The palette knife painting is most apparent along the bottom edge of the canvas slightly to the left of center. The remaining rock formations are more quietly painted in a combination of transparent and semi-opaque washes and drybrushing using large flats and filberts. The stand of dried grasses and shrubs in the center foreground are done entirely with drybrush. For the final work, I use small light and dark accents in the focal point and in the rock formation in the left foreground. Accumulated painting time from start to finish: about six hours.

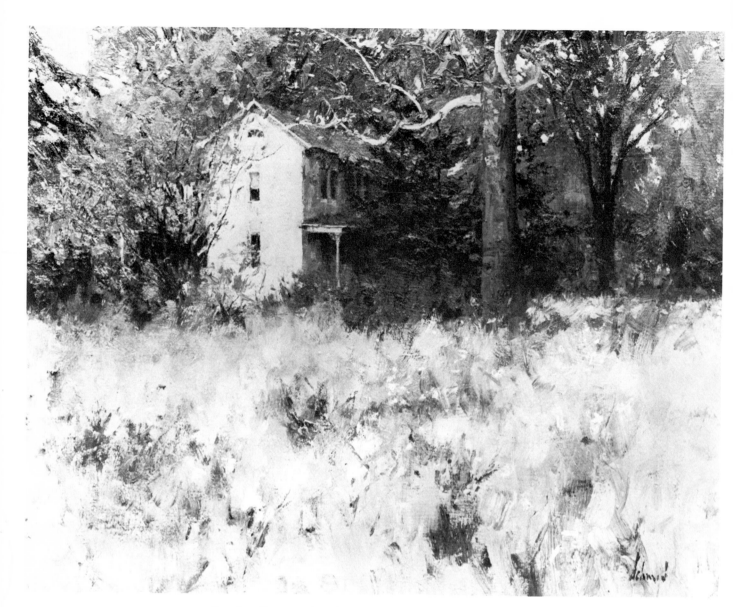

October Dooryard. Oil on canvas, 24″ x 30″ (610mm x 762mm). In starting this painting I used the combination of opaque and transparent turpentine wash described in the following demonstration. However, there was much more emphasis on color from the outset because it was October and the maple trees, which constitute nearly the entire background, were in full autumn color. This tone, a mixture of terra rosa and cadmium yellow, was applied quickly as a wash. This wash was overpainted with additional washes of viridian and cadmium yellow to produce a broken color effect. The principal darks were then applied with smaller bristle brushes—again as a transparent wash. The most important dark occurs under the porch of the house and, with the mass of light on the gable end of the house, forms the principal focal point. The secondary focal point is the large white branch of the sycamore tree in the center. The fluid lines of this tree and the other trees and brush act as a strong contrast to the stark lines of the house. The house itself was then developed. First with a semi-opaque wash of cadmium yellow and white, the light tones of the house were painted. Following this, minor details, such as the windows and the column and woodwork of the porch were added. I returned again to the brilliant light on the facing side of the house and repainted it with heavy, impasto palette knife strokes. The finishing involved drybrush work in the foreground and the addition of light and dark accents to all of the middleground and background trees.

There are as many ways to begin a painting as there are painters, but I find that a variation of opaque and transparent preliminary work is one of the safest. The categorization of "beginning," "developing," and "finishing" techniques is not clear-cut; there is a natural overlapping.

Nature has a way of being inconceivably repetitious yet, on a singular level, unique at the same time. It follows, naturally, that the greater the flexibility and range of techniques available, particularly in the early stages of a painting, the better. Conversely, the more rigid one's style, the less chance there is of fidelity to the subject. The diversity inherent in the combination of opaque and transparent painting presents more options at all stages of a painting than any other single technique I know of. This is because the scope of possible effects available between complete opacity and complete transparency constitutes the entire spectrum of oil-painting techniques. So this method of starting a painting is very similar to the standard block-in described in Demonstration 1, and even more closly related to the preceding demonstration. But the end result in all cases is subtly different, not only in the more obvious things such as subject matter and composition, but also in the less conspicuous aspects of painting.

The locale of this painting is just north of the confluence of the Ten Mile River and the natural course of the Housatonic River in western Connecticut. The Housatonic is divided at this point by a small island. The island is bridged on the west by this old iron and concrete structure and on the east by the still older covered bridge described in the preceding demonstration. I mention this because, while the two bridges are only about 500 feet apart, the effects conveyed in the two paintings are entirely different.

This bridge is a brooding and powerful structure. Its simple lines and values are in sharp contrast to the surrounding terrain. The abstractions of nature are everywhere—in the rushing forms of the water, in the character and variety of the trees and rocks, and in the delicate values formed by the remains of a late winter snowfall. My vantage point may seem a bit precarious—since the entire foreground is a white water rapids—but in fact, the river moves sharply to the right at this point and I was set up on the downstream bank. The cold and damp that day caused the canvas to slacken so that it was necessary to key up the corners on the spot before starting.

Except for the water, there was an overall tonality, almost monochromatic, throughout the entire area. Most of the values are in the middle-tone range, broken by dark values approaching and including black. The water contains the majority of lights and light halftones. The lightest lights are reserved for the few patches of snow on the left. There was no snow on the right because, being on the east bank, it had received full sunlight for several days and had long since melted.

This painting is fairly large for outdoor work—21″ x 36″ (533mm x 914mm). It looks like a lot to cover in one try, but I have painted much larger canvases in less time, so this is not at all unusual. The secret is to have a firm idea of what the finished work will look like and then work toward that concept methodically. Without some grasp of what the final effect will be it is easy to become overly preoccupied with one or another area at the expense of the painting as a whole. In some procedures a preliminary sketch or block-in is painted and the painting is completed in "layers"—usually finishing background, middleground, and foreground,

Demonstration

4

Opaque and Transparent Block-in II

in that order. In this painting, however, I have decided to paint in what might be described as an "order of priorities." In other words, after a preliminary wash is applied to establish the overall tonality, the separate areas of interest will be finished in order of importance. The bridge itself is the focal point. (Try to imagine the painting without the bridge and it will be obvious that one or another element in this scene would have to be strongly accentuated to make up for it.) The bridge area will be painted first. The secondary elements of interest are the tree groups flanking the bridge. Following this, the rapids and the rock formations on the lower right will be finished. This briefly will be the main order of finishing. It would seem to resemble direct painting as well as the standard block-in, which is characteristic of working with opaque and transparent methods. There is much working back and forth while at the same time maintaining the order of priorities I mentioned. At the risk of sounding repetitious, I must reiterate that whatever course is followed, it is absolutely necessary to have a strong mental picture of the finished work from the start. This is a working principle for all painting, but it is particularly important in working with large canvases.

Step 1. For larger canvases such as this, I use a medium-textured linen. This canvas has 62 threads per square inch and weighs 13 ounces per square yard. I rarely use anything heavier because the coarse-textured linen tends to overpower the paint textures, particularly in the transparent areas. Because of the excessive dampness of the this location, the canvas lost its normal tension. With excess humidity, the hygroscopic property of the glue size normally causes this to happen, so I always have keys with me to tighten the canvas. I usually remove them when the canvas is returned to a heated room and allow it to return to its original tension. If the canvas has been properly sized and primed, this will take care of itself in an hour or so. With this minor problem out of the way, I begin with a loosely applied transparent wash of cobalt blue, terra rosa, and yellow ochre. The cobalt blue is slightly predominant in the center because the tone will constitute part of the cooler tones of the background. This same cool predominance is extended to the entire lower half of the canvas, where the cooler tones of the water and rocks prevail. The remaining areas flanking the bridge are warmer in tone. As soon as the excess turpentine evaporates, I apply the major darks of the bridge with a mixture of ivory black and burnt sienna thinned with turpentine. A few lines are added on the left to indicate the line of the hill and the river's edge. By this time my palette needs cleaning, because the next step involves some clean color. By the time I am ready to resume work, the canvas is dry to the point where this transparent paint will not intrude into the overpainting that follows.

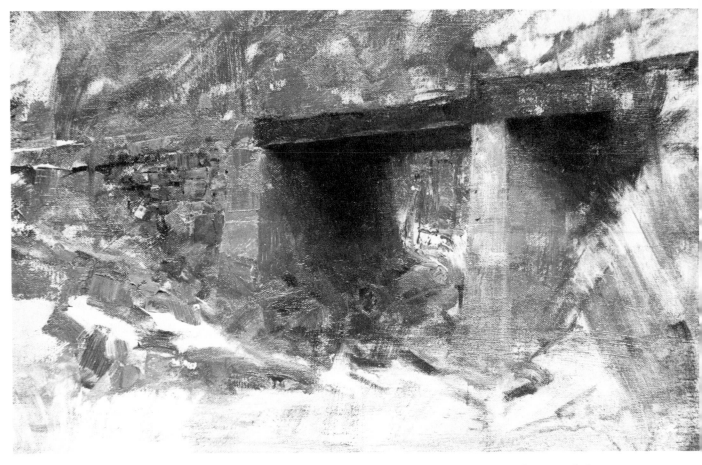

Step 2. This stage is shown as a detail of the central area of the canvas because virtually all my attention was given to finishing the bridge first. Because it is the dominant object, I render the bridge to a point of near-completion so that the remaining areas will not be carried to the point where they might predominate. This was no problem because the simple masses of the bridge are so strong that I would have to deliberately complicate the shapes in order to lose it. The problem, if any, arises later, when the rapids are painted, because of the activity and life that could easily steal attention from the bridge. The edges of the two darks forming the underside of the bridge and the soft cast shadows on the concrete supports painted in Step 1 are softened by drybrushing and palette knife painting. The concrete piers are old and beautifully weathered; I use drybrushing in the right pier and mostly palette knife strokes in the left. The stone blocks on the left, forming the support for the bridge approach from west, are also rendered with a palette knife. After indicating the darkest darks, as well as the structural parts of the bridge, I apply the lightest lights—pure white from the tube—with heavy knifestrokes. The edges surrounding these strokes are carefully shaped and softened with the middle tones of the hillside, using large bristle brushes. Before turning to the rest of the picture, I make some final touches. These consist mostly of colors and values added above and behind the bridge. These tones serve to establish the edges where the bridge meets the background; they also serve as the underpainting for the background itself.

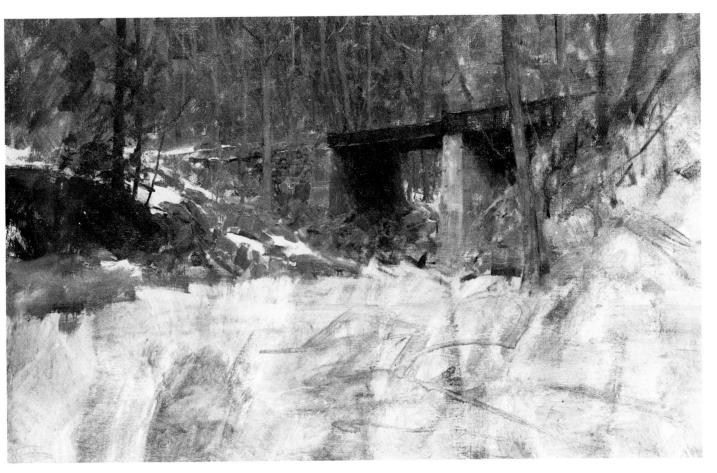

Step 3. In working outward from the bridge, it looks like a process of direct painting. The trees to the immediate right and left and the background seem to be finished. Actually, what is seen here represents a lot of painting and repainting. As I continue working around the bridge, the process is a series of secondary block-ins, each in turn overpainted with broken color and overpainted again with more carefully drawn shapes to represent the more tangible things—trees, rocks, etc. The very dark values on the far left, for example, show the beginning of what will eventually be a complex thicket of trees, brush, and rocks. An underpainting of background color and value has been applied and over this I have painted three of the many trunks and branches in the area. Immediately beneath these darks are some middle tones and a light value. This serves as an underpainting for a group of rocks and a patch of snow at the water's edge. Preparatory work is also in place in the upper right corner of the canvas. It consists mostly of lightly drybrushed tones as an underpainting for a dense group of trees that will be painted in the final stage. A very slight indication of the trees has already been brushed over the area to suggest their eventual placement. The slender black birch to the immediate right of the bridge has been painted to near-completion with alternate palette knife strokes and brushwork. This is the most important single tree in the picture and I will subordinate all of the others to it.

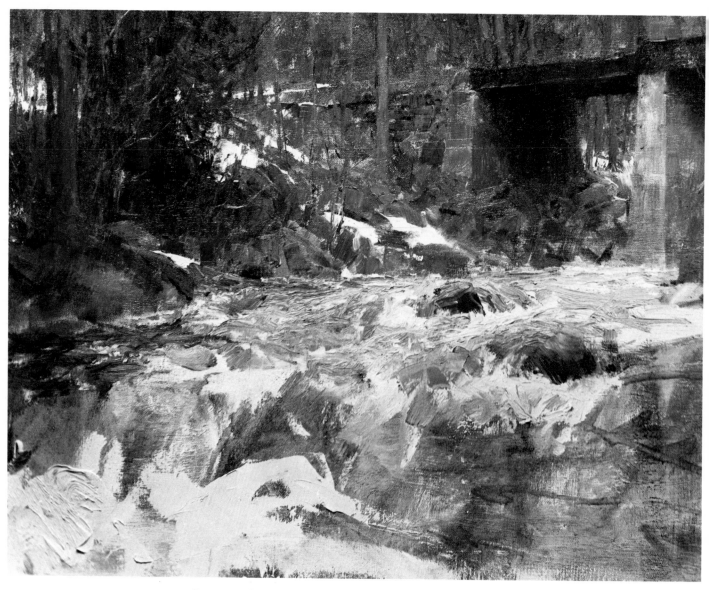

Step 4. This step is shown in closer detail because so much painting seems to be happening at once. The entire left of the river bank has been brought to completion and a good start has been made in the center portion of the river. When water is in violent motion, as in this case, it takes on colors of its own rather than following its characteristic mirror-like patterns. As in the other areas, I apply an underpainting with bristle brushes, using a semi-opaque mixture of cobalt blue, yellow ochre, and white. Over this, the lightest lights in the water are applied with a palette knife. This value is white and cobalt blue, slightly darker than the patches of snow. Still using the knife, I paint the dark values of the boulders in the river. Finally, I work into all this with a middle tone and light halftones of cobalt blue, yellow ochre, terra rosa, and white. Most of the brushing consists of strong lateral strokes of a small bristle brush. This final brushing serves to correct all the underpainting and create the finished edges. The tree group on the left is completed with final overpainting and brushworking from the trees in back to the distinct few at the water's edge.

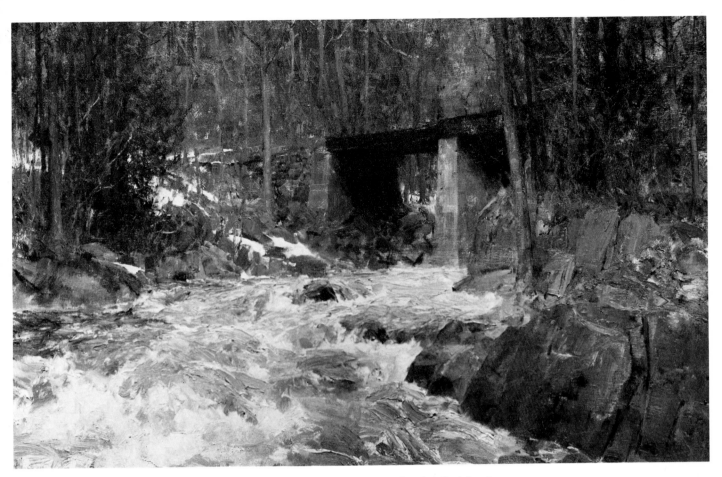

The Bridge. Oil on canvas, 21″ x 36″ (533mm x 914mm). The finished stage is a far cry from the simple statement shown in Step 1. This monochrome reproduction is slightly deceptive in that it seems like a very busy painting—and a dark one at that. Actually, while there are many elements here, the overall color in the original has a strong unifying influence and the bold values in the bridge retain their integrity much more than may be apparent. In this stage, I continue downward and to the right, finishing the rapids in the same sequence of underpainting and overpainting described in Step 4. The only unfinished areas, the hillside on the right and the massive boulders on the lower right, were approached with caution because I wanted to draw as little attention as possible to them. The rendering, therefore, is simple and undramatic. The boulders are finished with gray tones, using drybrushing and thin palette knife strokes, with some simple darks to vary the shapes. The hillside above is completed in broken color, almost impressionistic in effect, with only three or four trees accentuated—just enough to explain the area without drawing attention to it. As I mentioned earlier, this is a larger than average canvas for outdoor work, but all things considered, I am satisfied with the result.

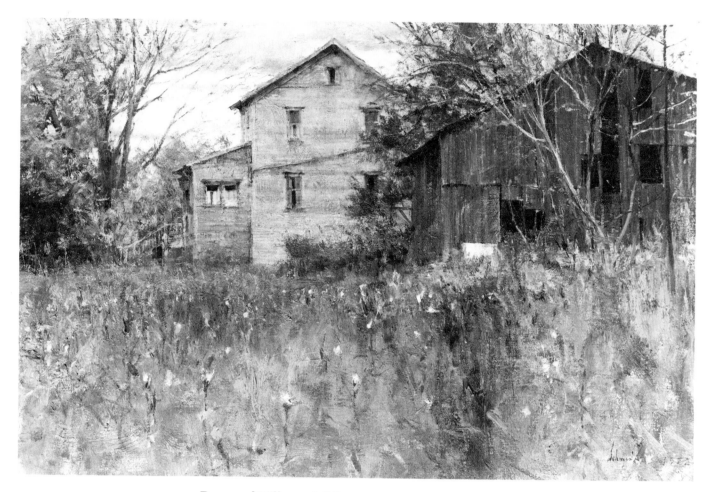

Dooryard Milkweed. Oil on canvas, 20″ x 30″ (508mm x 762mm). This is another late autumn sketch with the characteristic overcast of the season. I found this old farmhouse and barn in one of the Allegheny Mountain valleys in central Pennsylvania. The value relationships as seen in black and white above are farily close to the original in color. The overcast sky was darker than I would have liked, but it had a brooding quality about it that was very appealing. The total effect, however, was a low color scene—more of a value study than anything else. I began with the house and the barn because they dominate the painting not only in area but in interest—the dark barn contrasting conveniently with the lighter tones of the house. I began with an overall tone of cobalt blue and yellow ochre applied as a light transparent wash with the ochre predominating. A few perpendicular lines were drawn to align the house and the barn accurately. The darkest darks were then added as a deep transparent mixture of ivory black and burnt sienna. The most important dark is under the eaves of the farmhouse, particularly on the left, where it is sharply outlined against the light values in the sky. The next dark in order of importance is under the eaves on the left side of the barn. This is the main (and practically the only) perspective line in the picture. The secondary darks occur in the rectangular openings on the facing side of the barn, the windows in the house, and the darks in the tree and brush on the left. With all of this complete, the remainder of the block-in was finished with semi-opaque paint. The stages leading to the completion of the painting were identical to those in Demonstration 4. The final touches were the small darks and lights of the milkweed pods.

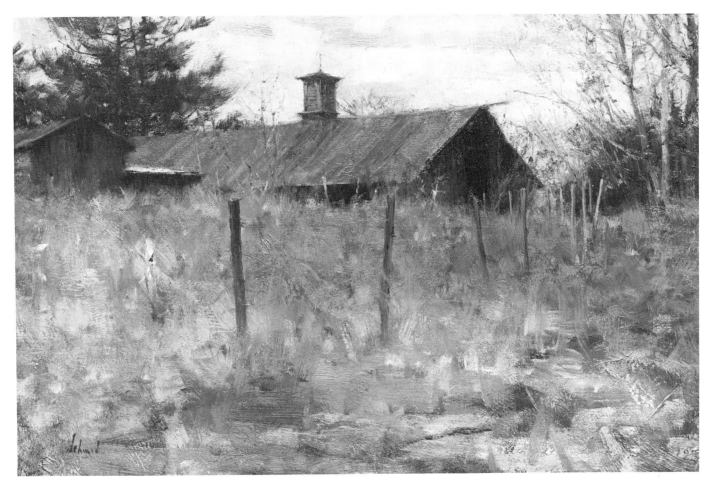

Sherman Barn. Oil on canvas, 14″ x 22″ (356mm x 559mm). At the risk of repeating myself I present yet another barn, and for better or worse, there are more to come. I am not particularly enamored of old barns, at least not in a nostalgic sense. There just happen to be a lot of them in my vicinity. Time and overgrowth have imparted to them a certain appealing character—something lacking in a shopping center or a bowling alley, for example. I realize the latter are probably more valid signs of our times than this old barn, but it is not my intention to illustrate the contemporary scene except when I am moved by it to say something worthy in paint. The painting is presented as another variation of the approach shown in the Demonstration 4. The same general sequence was followed—a preliminary transparent tone over the entire canvas followed by the application of the principle darks and middle tones, working back and forth with opaque and transparent paint. This completed the preliminary stage. The finishing work involved opaque paint almost entirely. With the exception of the trees on the extreme right and left, the painting consists of only four simple masses: the sky, the roof of the barn, the darks in the barn and outbuilding at the left, and the foreground. These simple masses are made meaningful by the use of edges and the inclusion of minor details—the cupola on the barn is the most important detail. The progression of fence posts give a sense of perspective to the scene and the milkweed (again) on the left and other small accents throughout the simple masses help to vary and explain the masses.

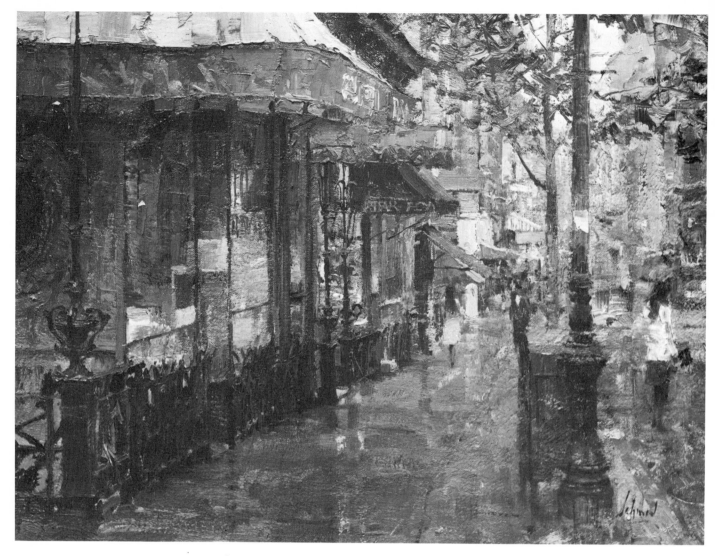

Manhattan Street. Oil on canvas, 12″ x 16″ (305mm x 406mm). Here is a contemporary scene, one in which countless thousands of people have probably been a part of without *seeing* it. The situation was not an easy one. The final effect in color as well as here in black and white was highly impressionistic, but because of the underlying perspective problems and preponderance of geometric shapes, I chose to do a full-value monochrome wash before going into color. I did not want to be bothered with drawing and value problems once the color work began. This was a late spring afternoon and just as the block-in was in its final stages, a very brief rain shower passed over. It was not enough to interrupt the painting, but it was just enough to give the sidewalk and pavement a highly reflective surface, which picked up many of the lights and colors from the shops on the left. Naturally, I took this as a sign of approval from Mother Nature and painted in all of that color before the rain evaporated. I then continued a little more leisurely to paint and finish those elements that would not change much in the hour or so of remaining painting time. I worked the finishing stages in layers, from the distance up to the nearest objects. I chose only a few figures for the last touches.

This is a nice, safe way to handle complicated subjects when brilliant color is not particularly important. In this case the actual color in the subject is so gray and subtle it could be rendered with a "limited" palette. This is reminiscent of the old academic approach to teaching color. A student would spend a year or so painting with only black and white from a subject such as a plaster cast. After mastering values, shapes, edges, and the general manipulation of paint, earth colors were added, one at a time. The idea was to sneak up on color gradually.

Even after the impact of Impressionism, this obsolete concept continued. It is still widely practiced today and still a colossal waste of time. The rationale was: the fewer colors used, the more harmonious the final effect will be. There is no argument against this except that the final result will very likely be harmoniously dull. I feel the monochromatic or limited palette approach is valid only when the subject itself is subdued in color. This is true only as applied to landscape painting. In figure painting, for example, the problems in drawing and value can be so difficult that this is the only workable approach.

This subject presents an intricate drawing problem as well as quiet color, so the monochrome wash block-in is appropriate. The idea is to work out all value and drawing problems, including edges, before application of opaque paint. Corrections are a lot easier to handle when there is a minimal layer of paint on the canvas. In this case, after the volatile spirits of turpentine have evaporated, there is little more than a stain on the canvas. This can be pushed around indefinitely until everything is in its place.

The turpentine wash can be carried to various extremes. If a bit of clean color is added during the rendering, it can be an end in itself—a finished painting in transparent paint. Whenever this is the case, the pigments used must be in the class of absolutely permanent colors. Thinning the paint to delicate light halftones will produce a fragile surface. The canvas must be carefully protected from abrasion and dust while it is drying. As soon as it is dry it must be varnished with a series of light sprays of damar. (*Brushing* with varnish will probably remove the painting.) If lightfast pigments are not used, varnishing will not help much. The only solution is to hang the painting in a dark closet permanently.

It is also possible to bring the turpentine wash to the point of photographic realism. That is all well and good, but unless it is an end in itself, it is just a waste of time and nearly impossible to overpaint. If the block-in is too precise and complete, the effort to conform to it in subsequent stages will lead to a very stilted rendering—a little like painting by numbers.

The intent, then, is to render a transparent wash that is loose yet accurate. It should be a working guide that serves as a foundation for the finishing process without at the same time being a hinderance. Ideally, it should be rendered so that a substantial percentage of the transparent darks remain untouched as part of the finished painting.

This subject presents some interesting problems. The old iron fence is quite a display of nostalgia—too much, in fact. I am as sentimental as anyone else, but I don't like to dote on something simply because it is old. The problem, then, is to do justice to the fence while maintaining the drama of the painting as a whole. I use two devices to accomplish this. The first is a heavy emphasis on the imposing lines and dark values in the

trees. The second is a vantage point that produces unusual perspective lines. With these two quietly dominant forces at work, I can preoccupy myself with the delicate tracery of the fence with no worries that it might get out of hand. The shape of the canvas also helps to emphasize the perspective lines. The ratio of the dimensions of this canvas is approximately 2 to 1. That is, it is nearly twice as wide as it is high. I like to use this ratio whenever I can, especially for landscape painting. It leads to interesting compositional opportunities and, curiously, it is very close to the way we really see. Although we have nearly 180° vision without having to move our heads, what we actually comprehend at a particular glance would fit into an imaginary rectangle with a ratio of 2 to 1.

Step 1. I mentioned earlier that the shape of this canvas is important to the composition. A modified rectangle or a vertical canvas would convey an entirely different effect. The way in which a canvas is toned is equally important. In the canvas above, I want to show the tone as it is before any painting begins. I know in my mind's eye what the finished work will look like and this tone is applied with that concept as a guide. I know, for example, that most of the hard painting will take place in the upper half of the canvas and that a good percentage of the original tone will remain untouched as part of the finished painting in the lower half. The transparent tone is, therefore, applied in a more interesting and varied manner in the lower half of the canvas. The upper half receives a minimum amount of tone. In this case, the tone is applied with a large bristle brush, using a mixture of burnt sienna and ivory black with a generous amount of clean turpentine. There are several areas on the canvas where the wash has run down the canvas a bit before evaporating. This is not the only way to tone a canvas. A faster method is to take a rag, saturate it with the tone, and quickly wipe the whole canvas, resulting in a more even tone. The canvas is usually ready to work on sooner because less turpentine is deposited on the surface. Another good but more tedious method is to do without turpentine altogether. A generous amount of the tone is prepared as a normal opaque mixture. This can be picked up with a large brush or rag and scrubbed into the tooth of the canvas. The excess pigment is then wiped away with a clean, dry rag. Still another but less desirable way is to tint the ground of the canvas when it is being primed. A small amount of color is added to the white lead and the prime coat serves as the tone as well as the ground. I said this is not the best way because an off-white ground lacks the optical properties of a white canvas and subsequent transparent tones will naturally lack brilliance.

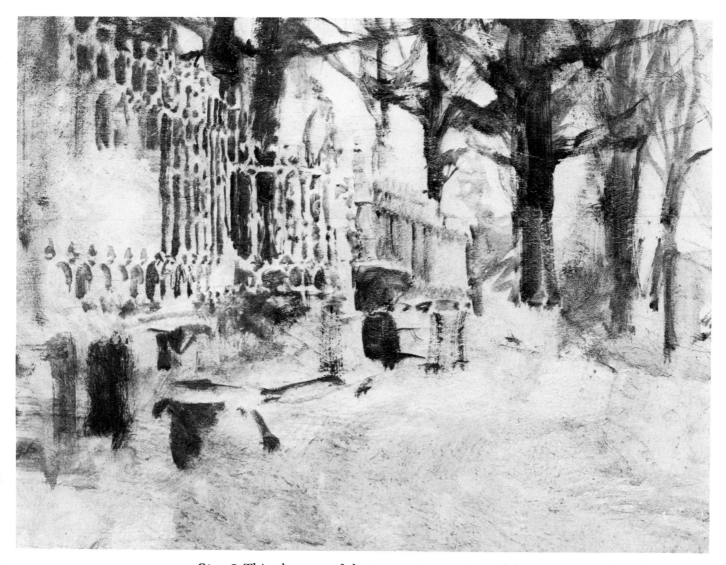

Step 2. This close-up of the top center portion of the canvas is where the real work begins. The perspective here is simple since there is only one vanishing point. The fence is so irregular that a little deviation from strict perspective and vertical alignment is desirable. My actual starting point was the dark value at the base of the gatepost in almost the exact center. This value is a transparent mixture of ivory black and burnt sienna with the black predominating. The left edge of this dark forms the main focal point of the composition. Using this transparent wash with the burnt sienna predominating a bit, I painted the darks in the fence openings working toward the left. It is unnecessary to actually draw the fence, since a rendering of the darks outlines the fence at the same time. The section of the fence to the right of the gatepost turns away slightly, leaving no spaces visible between the ironwork. The section, then, is treated as a simple value area. With the fence off to a good start, I turn my attention to the values and shapes that make up the complex of trees. The dominant tree is the huge dark maple at the right end of the fence line. All the brushwork in the trees is done with small and medium bristle brushes, using the same mixtures already mentioned. In this detail, the texture in the canvas ground is conspicuous in the area of the trees on the right. Some of this will have to be smoothed down to avoid glare in the darks.

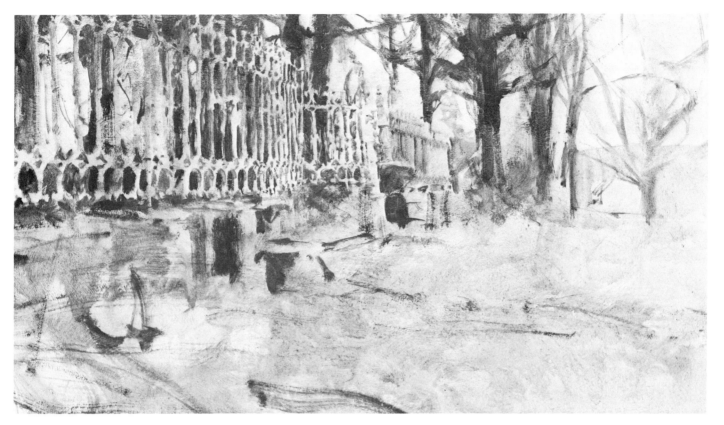

Step 3. The transparent wash is nearly complete at this stage. All the iron-work in the fence has been placed—or rather, not placed, since it is delineated by what is behind it. This, of course, will not be the case in the finished painting because the ironwork is a beautiful study in subtle grays and reds. A distant tree and house are added on the extreme right. Beneath the fence there is a foundation of stonework forming a line of dark halftones interrupted in the center by the light value of the gatepost. With this done, the finishing process can begin. With a block-in as complete yet loose as this one, I could start the finishing work almost anywhere. From experience, however, I know that I can save a lot of correcting and repainting by continuing here with the values in the sky. This step is necessary in finishing because it will enable me to paint into wet paint when I work on the trees. This way I can get the edges I want with a minimum amount of reworking. At this point I must mention the phenomenon of value relationships that occurs in landscape painting more noticeably than in studio painting. A large area of light *appears* to be brighter than a small area even though, in reality, their brightness is known to be the same. This occurs most often in painting trees, whether they are in full leaf or bare. The interlacing pattern of darks formed by their branches against the sky produces shapes of light that vary in size. Even though the sky behind the tree is uniformly bright, the smaller shapes seem darker. The value decreases or increases with size. The same is true in reverse for dark values—a large area of black seems darker than a small one. This is also true of color—an entire wall painted red will seem redder than a small spot of the identical color. The way to deal with this is to always paint what is *seen* rather than what is *known*.

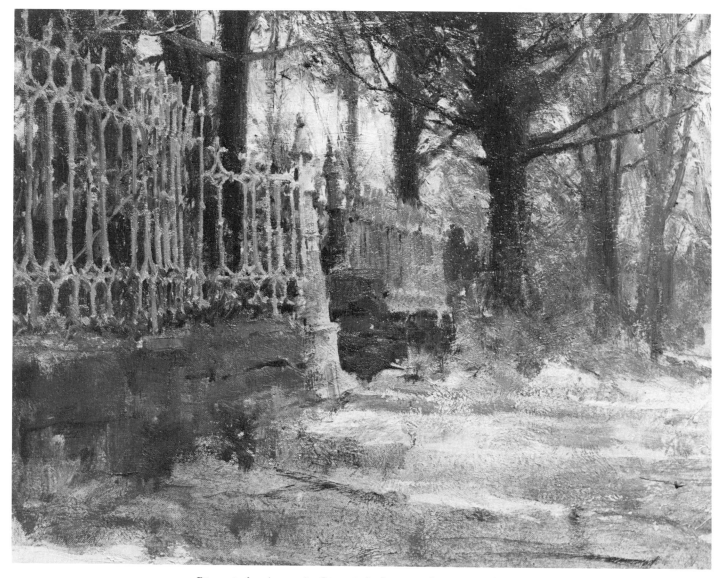

Step 4. Again, as in Step 2, I show a close-up of the central portion of the canvas because most of my efforts are concentrated here. I mentioned in the preceding step how the first application of opaque paint is in the values that constitute the overcast sky behind the trees. This also amounts to an underpainting. In applying this, I brushed slightly into the transparent darks of the block-in so that when the trees are finally painted, the adjoining values will have a rich variety of edges. There is a temptation when applying opaque paint over a meticulous block-in, to paint up to the edges of the various shapes in the canvas for fear of "losing" the drawing. This practice is fatal if the work is to be rich in edges. It resembles the way in which a child fills in the lines of a coloring book. I got this out of my system long ago. Even if I "lost" the drawing by obliterating it entirely, I could reclaim it easily because if I drew it once, I can draw it again. So with the trees and sky worked back and forth with a palette knife and small filbert brushes, I return to the focal point—the iron gatepost in the center. The dark values at its base are hardly touched. Most of the painting is devoted to subtle value and color changes along the length of the post.

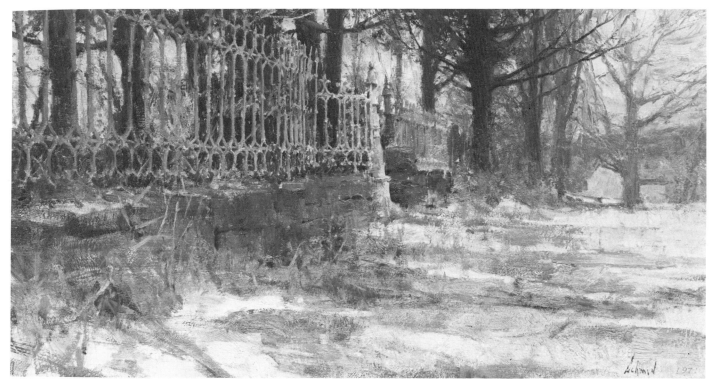

Iron Fence. Oil on canvas, 16″ x 30″ (406mm x 762mm). Finishing the fence toward the left, although tedious, will be worth the trouble. The problem does not only require delicate drawing and brushwork, it is just plain hard work. The real problem lies in preventing an overly fastidious rendering. I have never viewed hard work as a virtue in itself. Such painting is closer to crocheting and is more an homage to endurance than art. The approach, then, is to paint the fence in a slightly irregular manner—a kind of "lost" and "found" technique. I exaggerate parts of the ironwork with sharp edges and subdue other parts with soft or lost edges and values that merge with adjacent tones. In this final stage the gatepost in the center here is the prime focal point, but then the fence gradually diminishes and almost disappears at the left edge of the canvas. Nearly the entire fence is rendered with small round sable brushes and a large palette knife. In painting the fence, the dark tracery of the background trees is worked at the same time so that the edges can be fully integrated. The stonework below the fence consists of alternating drybrush strokes and palette knife painting. The drybrush work is clearly seen on the extreme left. The palette knife is used in two ways, both in the stone foundation and in the foreground. In the stones toward the center, paint is heavily applied with lateral strokes of the knife. In the lower course of stones, this paint is then scraped downward, softening the transition between the ground and the stones. The foreground is rendered in the same manner with drybrushing and applications with the palette knife and subsequent scraping. This combination of brush and knife painting as well as the original tone applied in the block-in of the foreground, creates a variety of textures with a minimum amount of paint. I do not want to draw too much attention to the foreground. It should be interesting in a quiet way. This is not the most difficult painting I have done, nor is it the easiest. Working out the problems in the fence requires more concentration than the average painting.

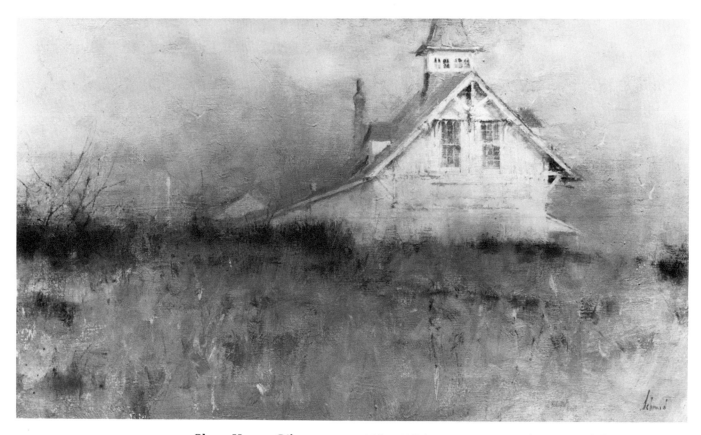

Shore House. Oil on canvas, 16" x 30" (406mm x 762mm). I painted this beautiful, decaying structure during a painting trip along the eastern seaboard of the United States. This is somewhere along the New Jersey coastline in a protected area known as the National Seashore. It was late October and the weather was bitterly cold and uncertain. In the "off" season, this area is a sort of no-man's land. The sun bathers and fishermen are gone and the shore is left to the gulls and other birds, like myself. The gray loneliness of this house was subtlely magnified by a low, rolling fog coming in from an offshore wind. This caused the sky to darken toward the horizon—the reverse of what usually happens. (An average, clear sky tends to be darkest at its zenith.) The subject and atmosphere produced a simple value study—the sky and foreground being nearly equal in value, a dark value running horizontally across the center of the canvas, and the light value of the building dominating the composition to the right of center. A minimal block-in was all that was necessary to prepare for the finishing work. This consisted of a transparent wash of cobalt blue and yellow ochre in the sky with the blue predominating. The same wash was applied to the foreground with the ochre predominating. The dark value was then painted across the center using burnt sienna and cobalt blue. Finally, the light value of the house was created by removing the tone of the sky with a clean rag dipped in clean turpentine and corrected with the addition of transparent middle tones with small bristle brushes. From this point the painting almost painted itself because the preliminary work, although brief, amounted to more than enough block-in, and except for the careful brushwork and palette knife painting in the main structure, the colors and values of the transparent wash required very little alteration. Aside from the house, the finishing process was mostly a matter of creating a few realistic effects in the dark values, such as the low branches on the extreme left to give them some identity.

The term "simple" in this block-in technique should not be taken literally. It is only relatively simple in the sense that it is not carried to the extent that a full-value block-in is. This does not mean that there should be any less concern for accuracy in the drawing and values. (The term "drawing," of course, is not drawing in the linear sense. It refers to the size and shape of colors and values in a painting.)

It is self-evident in most cases, that the less preliminary work required in a painting, the better. This demonstration is an example of how little is required before the opaque rendering can begin. Its main benefit is the extra margin of painting time in the finishing process. Like a full-value block-in, it is used for subjects and light conditions with low color effects.

The canvas size I chose—16″ x 24″ (406mm x 610mm)— is about average for a landscape. There are many factors to consider before choosing the size and shape of a canvas. Available painting time is one. A huge canvas (or sailboat, as it is called) would obviously be a poor choice when painting time is very limited. Another consideration is the intended composition. The shape of the canvas—long and narrow, vertical, square, etc.—partly determines the way the observer's eye travels across the surface. Finally, as in many other things, bigger is not necessarily better. Many effects are conveyed with greater force on a modest size canvas. There are certain qualities of subtle intimacy that are dissipated if attempted on a large format. The work of Vermeer is a perfect example of this. On the other hand, some subjects are so grand they almost cry out for a giant canvas that will engulf the observer. The sweeping canvases of Joaquin Sorolla at the Hispanic Society in Manhattan and Monet's series of water lilies are splendid examples of what huge size can do.

One of the most common mistakes made by beginning painters is working on canvases that are too large. A general rule for students is never to start a canvas so large that it cannot be easily finished in about three hours. As working speed and accuracy increase, canvas size can gradually increase also. It is all a matter of experience and judgment.

This old brick house is in central Iowa. I grew up in the Midwest, so the character of the land is nothing new to me. The land itself is anything but spectacular, unless its overwhelming flatness can be sensed. In these days of superhighways and air travel, most people never see the rich landscape that abounds everywhere. It cannot be even remotely appreciated while speeding along at 70 m.p.h. or looking down from 30,000 feet—but it is there for anyone who will take the trouble to leave the beaten track and venture down side roads.

On this a gray day in spring, painting time is limited to an afternoon's work. Color and light are subdued and the pictorial elements are few. There is only the house, a hedgerow with a white pine, the overcast sky, and a broken foreground. A quick, simple monochrome wash will be the quickest way to get started. A few accurate shapes and values will act more as a guide than an underpainting. The monochrome wash will be carried only far enough to establish the size and placement of the house and the line of the hedge. To kill the dead white of the white lead ground, I will apply a thin wash of cobalt blue and yellow ochre. Just to the right of center I will draw a perpendicular line where the house is to be placed. I usually do something like this whenever I have architectural or other geometrical elements in the scene. It acts merely as a guide to prevent the

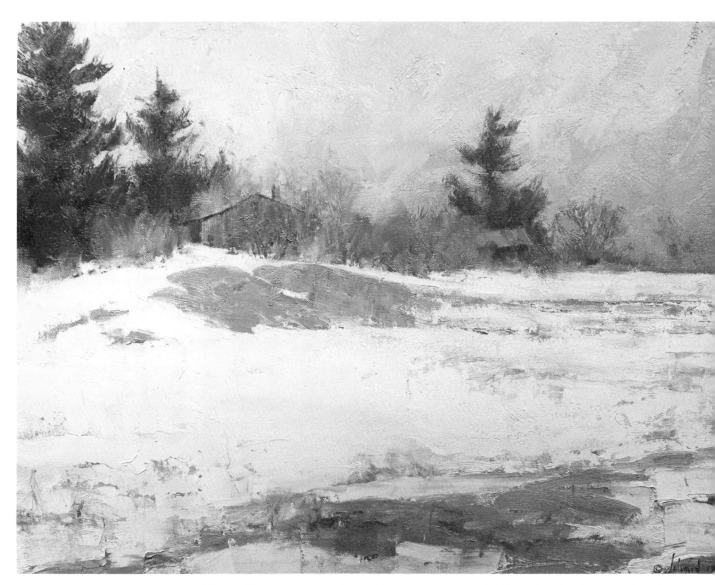

Pines. Oil on canvas, 16" x 20" (406mm x 508mm). There is a fundamental similarity between this painting and the painting of the "Shore House" shown on p. 90. This value study involves the same three value masses, only with a different distribution and emphasis. In this case, the three pine trees (the darkest elements) dominate the composition, while the middle tone of the sky and the lighter value of the snow are relatively quiet. There are two small outbuildings that are part of a fourth value, a dark halftone running horizontally across the canvas at the base of the pine trees. The two structures are delineated solely by the darks within their eaves and side walls. It was necessary, then, to paint a simple value rendering without regard to color as a beginning. Again, I prepared the canvas with a general tone—a transparent mixture of cobalt blue and yellow ochre. The dark tones of the trees were then painted with medium bristle brushes with rich, dark mixtures of viridian, burnt sienna, and cadmium yellow. This is a departure from the strict monochromatic wash, but in this sketch there was no definite separation between the preliminary work and the finishing work. This transparent tone remained as a finished dark in the final stage. Both the sky and the foreground were entirely finished with heavy palette knife painting.

perpendicular lines in the house from leaning too much one way or another. A certain amount of misalignment is natural in any old structure, but too much will make the house look like it is going to fall over.

I will add a pine on the left as an afterthought. The pine is actually an elm that is about 50 yards farther to the left; but because the left side of the canvas will seem empty, I will borrowed the tree, change it into a white pine—because I like pines better than elms—and move it closer to the house. The term for this is artistic license. I did somewhat the same thing to the scene of the iron fence in the preceding demonstration. Anyone comparing the actual location to the painting will note several apparent discrepancies. I was merely adding things and pushing them around until I was happy with the result. It is, after all, the result that matters.

The general sequence in this painting will be first, a light, transparent tone on the entire canvas; second, a plumb line; third, the monochrome block-in; and finally, the opaque painting. The opaque painting will also be done in stages: the sky, the house, the hedge, the lilacs, the phantom pine tree, the foreground, and finally some minor reworking of all areas to bring the painting "together."

This painting will be entitled "Lilac Hedge" simple because there is a stand of lilacs emerging from behind the left side of the house. Giving a title to a painting can often be quite a problem. With a portrait it is just a matter of identifying the subject. With a landscape, still life, or nude, it is another matter. For example, what can I call a picture of someone without their clothes on but "Nude" or "Figure," or the like? Some Victorian painters seemed to have an undeclared competition for nauseating titles such as "Nymphs at Play," "The Prey of Cupid," or simply, "Yum-Yum." Landscape painters fared no better with titles like "Nature's Wonderland" or "The Fairy Woods." Some contemporary avant garde painters are just as bad—but in the opposite direction. Their titles are cryptic to the point of nonsense or so lengthy that the title amounts to an explanation of the work. Most often I name a painting merely to identify the location or some other tangible aspect. I often wish I could simply number them in the sequence in which they were painted.

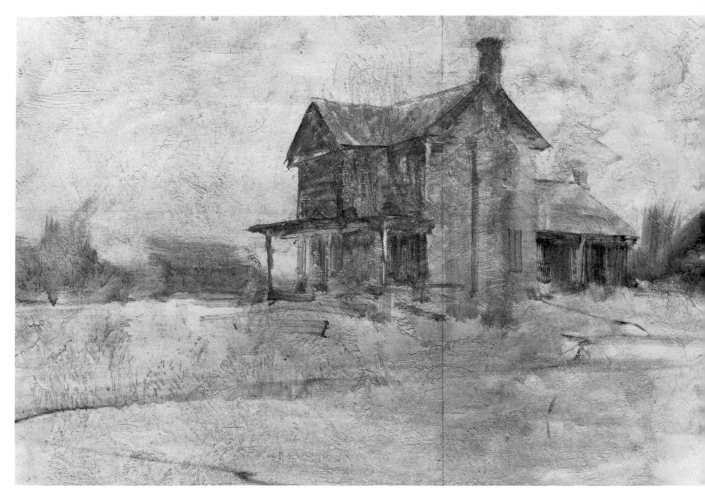

Step 1. The canvas for this painting is the usual medium-textured linen primed with white lead. The texture of the prime coat is clearly seen at this stage, particularly in the sky and foreground areas. This texture will be helpful in the later stages of the painting. In three small areas—under the porch and under the eaves of the roof on the right and left—I scrape the texture smooth to minimize any glare that might result from high spots. These are the principal darks on the house and they must remain transparent. I prepare for the block-in by first applying a light transparent wash of cobalt blue and yellow ochre with a large bristle brush. When this dries, I lightly wipe the surface of the canvas to accentuate the texture. Following this, I draw the perpendicular line just to the right of center. All of the vertical lines of the house are measured against this. The line will eventually be removed in the finishing process. The block-in of the house begins with a turpentine wash of cobalt blue, yellow ochre, and a little burnt sienna. With the exception of the light and dark accents, the values at this point are very close to the values in the final stage. The middle tone flanking the house on the right and left is only approximate. Little, if any, work is done beyond two vague diagonal lines that act somewhat like perspective lines leading into the picture. I am also violating two sacrosanct rules of composition by placing the principal focal point at dead center with the horizon line cutting the canvas exactly in half. However, the finished stage will not in the least seem equally divided.

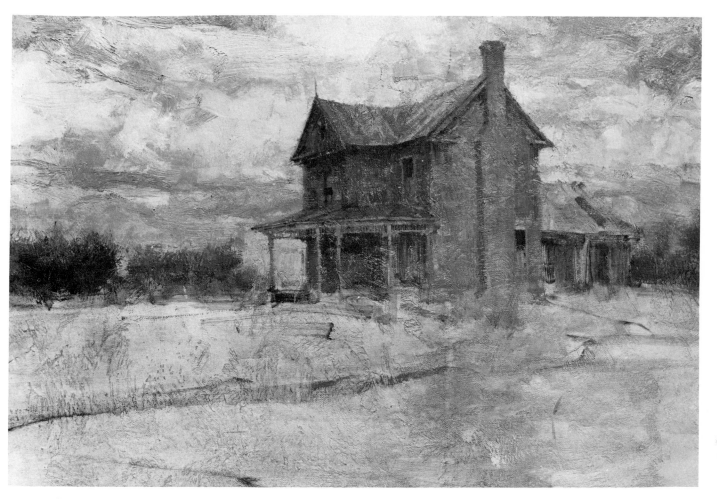

Step 2. The entire sky at this stage will be completely finished. This is a dramatic, low-lying overcast—one of the more difficult cloud patterns to render. The sky is also in motion, so I will go for it right away. In a moving overcast like this, it is hopeless to make corrections as it changes. It is also unnecessary, because while the clouds are not precisely the same from one moment to the next, they tend to repeat their patterns over and over. A gray sky is not gray in the sense that it can be done with a combination of white and black. It is a study in color and temperature changes. If it is not viewed in this way, it will look like a dirty wad of cotton. The general temperature relationship is warm lights and cool darks. Some of the darks, however, pick up warmth from light reflected from the ground. The mixtures in the light are cadmium yellow, yellow ochre, and white. For the darks I use cobalt blue, yellow ochre, and white. The sky is done in three stages. First I apply most of the darker halftones with a wide bristle brush. This is follow by all of the lights and light halftones, using the larger palette knife. The dark halftones are then repainted with a bristle brush and worked into the impasto lights, creating a variety of textures and edges. Next, I turn my attention to the house, working first on all the peripheral edges where the house meets the sky. This is followed by overpainting the block-in tone with the correct opaque color in the walls and roof. For this I use small and medium bristle brushes and mixtures of terra rosa, yellow ochre, cobalt blue, and white. The lower section of the hedge is painted in viridian, yellow ochre, and burnt sienna.

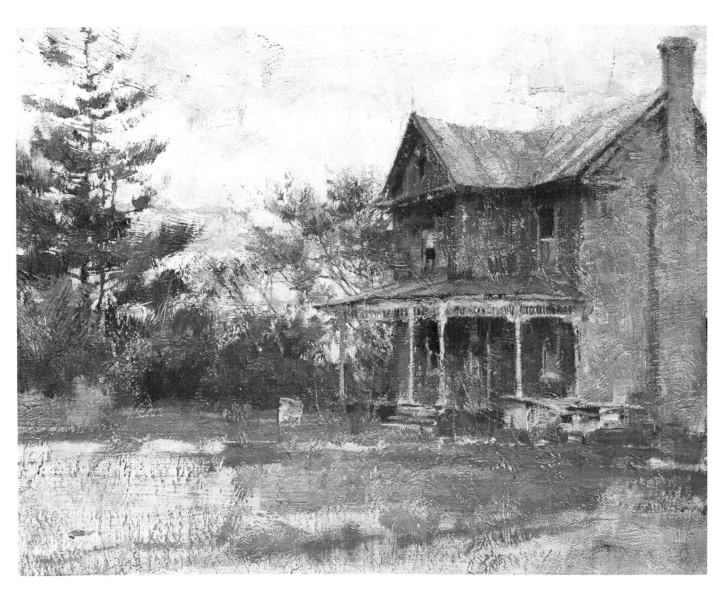

Step 3. This is a close-up of the central area of interest. The painting time up to the finished stage shown in Step 2 represents about an hour of work. At this stage I slow down a bit because most of the delicate work begins here. Continuing from the preceding step, I begin work on the unfinished details of the house. The dark accents under the eaves of the roof, the windows, and the woodwork on the porch require careful painting. Most of the intense darks on the house are applied with vertical strokes of a palette knife, using a mixture of ivory black and burnt sienna. The old woodwork of the porch lightly suggested in Step 2, receives a final overpainting. I work back and forth between the lights and darks with a small red sable brush and small palette knife, creating light and dark accents and lost and sharp edges until the desired effect is achieved. Along the left edge of the house, the lilac hedge serves as a modifying element, merging with the edges of the left side of the house and porch. The greens in the hedge are a continuation of the viridian, yellow ochre, and burnt sienna mixture of the lower bushes, but they are peppered with touches of pure cobalt violet and white to bring out the flowering lilacs. Finally, I paint the pine, actually a double-trunk pine, on the left. All of the foliage to the left of the house is rendered with the extra long filbert brushes to maintain a feeling of rich, loose brushwork.

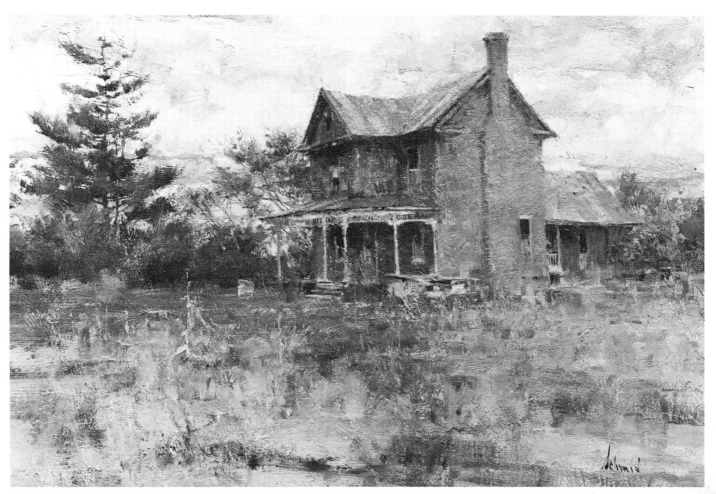

Lilac Hedge. Oil on canvas, 16″ x 24″ (406mm x 610mm). This painting, when it is finished, will be significantly lighter when seen in full color. This discrepancy in value is one of the unavoidable drawbacks of black and white photography. Since I am mainly a colorist, a true impression cannot be conveyed in monochrome, even in a low color scene such as this. In the finishing touches on the house, rich mixtures of cadmium red, yellow ochre, and white are drybrushed on the facing walls. All of the roof surfaces received additional pure color notes of cobalt violet, cobalt blue, cadmium yellow, and viridian applied as broken color. The overall color key of the foreground and middleground trees and brush is a warm green. The foreground receives a rich transparent wash of yellow ochre. Over this a few dark strokes of burnt sienna and viridian are drybrushed, following the lines originally applied in Step 1. This line is then inter- rupted with a light halftone of cadmium yellow, yellow ochre, and white, applied both as drybrushing and palette knife painting. The palette knife work is easily seen in the lower left and lower right on the canvas. The middle tone that joins the lower edge of the hedgerow is a clean mixture of viridian and cadmium yellow applied with a large bristle brush in strong horizontal brushstrokes. Finally, I add a few milkweed stalks that have survived the winter. The most conspicuous one is halfway up the foreground toward the left. I always look for incidental details like this to add interest to monotonous areas. Some final work is done on the exten- sion of the house to the right with a few dark accents in the window.

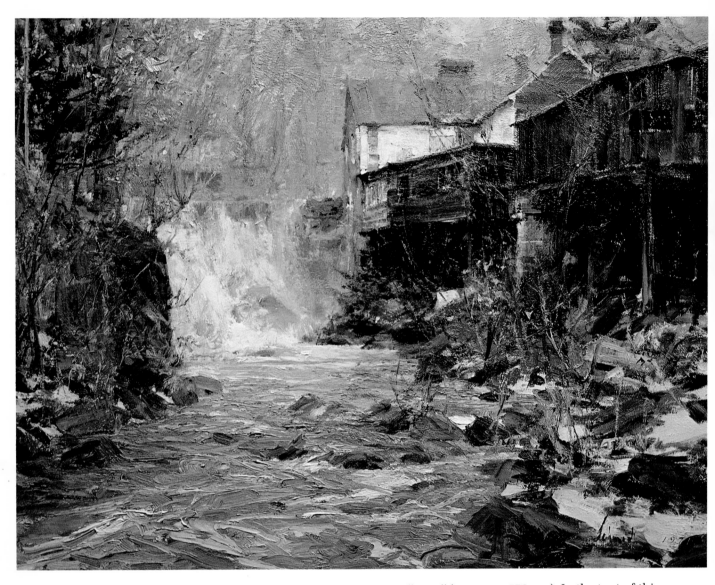

New Preston Falls. Oil on canvas, 28″ x 22″ (711mm x 559mm). In the text of this demonstration, I discuss in detail the use of direct painting techniques for larger and more complex paintings—works that might ordinarily demand a more cautious approach. The painting above is an example of how wide a diversity of objects and elements can be integrated within a composition without overcrowding and without a labored appearance. Consider the objects: a group of buildings, none of them symmetrical and all of them with different vanishing points and other perspective problems, not to mention their different textures and character. Along with this is a waterfall, a variety of trees and brush, a rushing stream, patches of snow, rocks and ledge, and a heavy atmosphere creating a background of rapidly diminishing clarity. It was possible to complete all of this in one session because the light was a typical late winter high overcast and it held steady all day. My first brushstrokes established the transparent dark areas under the two buildings on the left. This also gave me the first perspective lines. From there, using a palette knife, I placed all the light values in the center building (this is also the focal point). After that, it was a matter of placing one finished stroke after another, with a minimum of correction, until the painting was finished.

The majority of the techniques in this book are *alla prima* in the sense that their completion was largely accomplished in one working session. However, this example of direct painting is probably closer to true *alla prima* because there will be an absolute minimum of preliminary work. Generally this approach is used when the intention is usually a free, loose sketch, devoid of intricate detail but abundant in charm and honesty. These are invariably small canvases and they tend to convey a single statement—an effect of light, color, the prevailing design in the landscape, etc.

But direct painting is not necessarily confined to simple works. The same technique can be used for larger, more complex statements. The only extra requirement is that a little more painting time is needed. This demonstration shows the direct painting procedure, although the final result here is not as loose as it could be. The direct approach is a practical necessity in this case because there are two rapidly changing elements—the movement of people on the street and the gradually changing shadow patterns due to late afternoon sunlight. In addition to this, there is an intricate architectural pattern with its problems of perspective and texture—in other words, it is a typical street scene. With all of this to deal with, direct painting is the surest approach. After all, I could hardly ask all the people to stay in the same position while I labor on a complicated block-in.

In essence, direct painting is simply a matter of applying finished brushwork from the very beginning. It is that simple and of course, *that* difficult. At the outset, a point on the empty canvas is selected, usually the focal point, and a very brief turpentine wash is applied to indicate the salient darks. This can be done in a minute or two because the wash is confined to a small area around the point of beginning and *not* throughout the whole canvas. There is a point in placing dark patterns elsewhere because they will have changed by the time I get around to painting them.

Direct painting is a demanding procedure because it requires unusual skills. To start with, it is necessary to have a mental picture of the finished composition before the work is begun. This almost goes without saying because without this mental picture, I would have no way of knowing where to start and the result would be chaos. In addition, once I begin I am committed to a special kind of accuracy. Since this is a finishing process from the start and because painting time is limited, there is very little margin for error. Extensive repainting is out of the question. Each brushstroke must be the right size, shape, and color. Finally, it must have the correct edges relative to the brushwork adjacent to it and it must anticipate the stroke to follow—its thickness, viscosity, and direction must prepare the way for the next stroke without interfering with it.

All of this sounds nearly impossible and admittedly, it is not easy. But as the painting progresses, the work gets easier because more correctly finished elements accumulate and the nucleus placed in the beginning expands like a jigsaw puzzle into an increasingly coherent picture.

The hardest part is getting a good start. Once this is accomplished though, the work almost seems to finish itself. A certain stride of painting develops as one stroke leads to the next until the signature is at last placed.

Step 1. Before starting the actual painting, the canvas received a light, irregular tone of yellow ochre thinned with turpentine to warm the flat white of the canvas. In many areas this tone will remain untouched because it is the same color and texture as the subject. The placement of the principal darks is shown above. This is very quickly but carefully painted with a medium filbert brush and a transparent mixture of ivory black and burnt sienna. This simple start is the most important moment of the painting. In these few minutes I establish the focal point, the main value design, the horizontal and vertical alignment, the perspective lines, some architectural decoration, and the suggestion of figure groups. The vertical lines of the column in the center and the horizontal line of the arch are the initial strokes. These lines are first because it is important to immediately establish true alignment in order to avoid a progressive leaning effect. This kind of imbalance can be disturbing unless there is a characteristic irregularity in the subject itself. Even then, architectural lines that slant or sag in one direction are usually offset by other lines leaning in the opposite direction. If this were not so, the structure would eventually collapse.

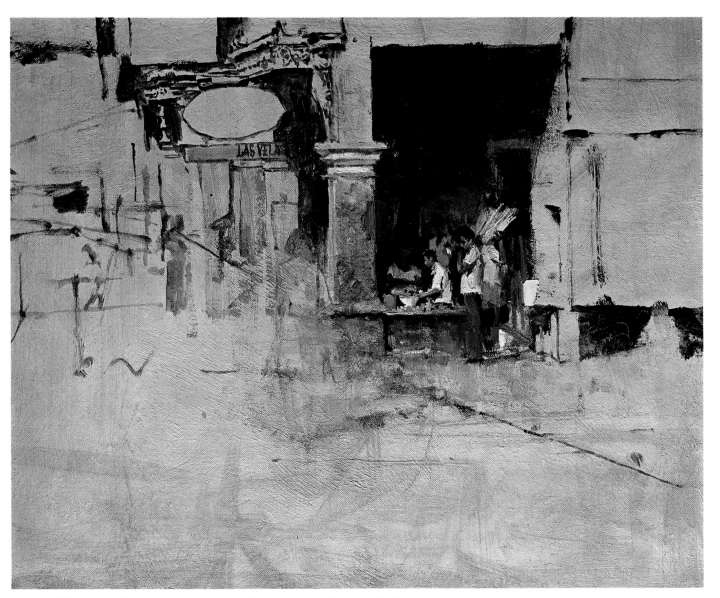

Step. 2. After the placement of the principal darks in Step 1, I work down-
ward to complete the figures and objects in the light under the arch. Fol-
lowing this, the subtle tones within the shadow are finished. This is the
characteristic sequence of direct painting. I completely finish one area
before moving to the next. The darks on the extreme right and the exten-
sion of lines and values to the left were placed *after* the completion of the
painting in the center. The dark values in the main shadow area are
thinly applied with medium filbert brushes. I try to avoid heavy brushing
that might catch highlights and diminish the transparency of the shadow.
Prior to this final application, I carefully scraped the area to nip off any
high spots in the ground of the canvas that might produce unwanted
highlights. The figure group is painted with strong impasto strokes to
contrast with the transparent shadow and produce a firm third-dimen-
sional effect. This is done with a small palette knife, small filberts, and a
small, round sable brush for minor details and accents. The preliminary
work extending to the right and left of the canvas is done with the same
brief but accurate application as the work shown in Step 1. A vague out-
line of a figure can be seen in the center of the canvas. I will not compete
this figure because I want to maintain the existing focal point.

Step 2. (Detail) This close-up of the main area in Step 2 shows the brush and knife work in greater detail. Three of the five figures in this group are in full sunlight. Of these three, I chose the seated figure on which to begin the direct painting. This figure is a natural choice because the value of his shirt and the values surrounding it constitute the lightest light and the darkest dark. The use of the knife and brush is very clear in all of the figures in the light. The knife alone is conspicuous in the flash of pure cadmium scarlet in the center and the thick stroke of white and cadmium yellow to the right of the figures. This interplay of the rich texture of the canvas itself with transparent and impasto brush and knife painting creates a surface quality impossible with a brush or knife alone. From the figure, my attention is turned toward adjoining areas; generally toward the left. The painting in the column is a combination of standard brushwork with drybrush painting over a warm transparent wash of yellow "gingerbread." My approach is to paint the character of the decor with occasional precise detail here and there to satisfy the eye. In this way the maze of an old facade can be painted expressing great detail without appearing overworked.

Guyaquil Street. Oil on canvas, 20″ x 16″ (508mm x 406mm). After the completion of the figures in Step 2, I continue to work toward the left of the canvas, finishing one small area after another. Most of my efforts are confined to the figure group to the left of the center column and the architecture above it. The area is crammed with detail so it is necessary to paint in a more or less impressionistic way while accentuating a few areas with a stronger, more literal technique. The approaching figure in the white dress is painted with a few simple strokes of a palette knife and then corrected slightly with a small filbert brush. This figure forms a secondary focal point. This whole area on the left is a delight to paint because it gives me the opportunity to use the whole range of painting techniques: drybrush, scumbling, impasto brushing, knife painting, and transparent washes. The remaining simple areas on the right are finished with a few light halftones applied with a palette knife and slightly over-painted with drybrushing. The entire bottom half of the canvas is finished in a few minutes with thin washes of cobalt blue and yellow ochre followed by some drybrushing to give added texture.

Fajardo Street. Oil on panel, 12″ x 16″ (305mm x 406mm). This painting was not as complicated as the street scene in Demonstration 7. To begin with, it is smaller, giving me more working time. Secondly, the majority of the picture area consists of broad, simple elements: a wall and a plain street surface. The point of greatest interest, the central figure group, amounts to only 10% of the picture surface. The variegated color of the street is the result of reflections caused by a rain shower. There was only one problem: people have a tendency to move. My approach, then, was to make a full-color wash rendering on the spot, concentrating on the unmoving figures and then finishing the sketch in the studio, using photos taken on the spot as a reference for the remaining figures. Only the three standing figures required the aid of photos. I began this sketch in an unusual way. My first tone was the opposite of, or complement of, the final color. For the broad areas, the first wash applied was a rich mixture of cadmium yellow, cadmium scarlet, and terra rosa. Over this, I applied subsequent washes of viridian and yellow ochre for the wall, and cobalt blue and yellow ochre for the street, allowing the initial wash to show through to create a scintillating color effect. Next, the seated figures were painted in turpentine washes and the placement of the standing figures was indicated by vertical strokes of their approximate color. I then went over the entire painting, duplicating the transparent wash with opaque mixtures. Finally, back in my studio, I applied the final touches and completed the standing figures.

This is another technique available when there is abundant working time for working out problems of brilliant color and intricate drawing. The subject here is an old Spanish Colonial villa along the Puerto Rican coastline. The effect of the clear, tropical sun on the stucco walls and tiled roof of the house is intensely high-keyed. This is strongly enhanced by the contrasting dark values in the foliage surrounding most of the house. The interplay of bright warm colors and dark cooler values creates a truly dazzling effect.

Since I have nearly all day to paint, which is more than enough, I feel that it would be pointless to begin with anything less than pure color. Briefly, my procedure will be to paint a full-color turpentine wash, almost as if I am doing a watercolor. The finished wash will be seen in Step 2. At that stage, it could almost stand as a completed painting, and perhaps it should be. However, I am interested in textural effects and other details that cannot be achieved by transparent rendering alone. The remaining steps, therefore, are an elaboration of the finished block-in. This "further elaboration" is not merely a superficial finishing process; it is a compounding of subtleties that, taken together, are an homage to a lovely and obviously enduring creation. (What stories it might tell!)

I could rhapsodize at length about the old house, but this discussion is about how it is painted rather than how charming it is. My feelings about it are obvious in the finished work, anyway. After the finished block-in, I will first work in the area of main interest—the central group of columns and balustrades. The bulk of my time in the finishing process will be spent in this area. This is the natural and logical area to finish first for several reasons. From the standpoint of drawing, it is the most complicated part of the picture. Besides this, it contains the principle focal point (where the right edge of the central column meets the dark value of the doorway behind it). Finally, the degree of "finish" in this area determines the extent of "finish" in the entire painting. Everything else will be related to this area in a way that will unify the composition. I could almost accomplish this in the transparent block-in. If I wish to maintain the painting as a transparent rendering, some additional work would be necessary in this same central area to reinforce it.

After working out all of the problems of color and surface texture in the center, I will turn my attention to the upper portion of the house. While working in this area, particular attention will be given to all of the edges where the roof and walls meet the background. From the final stage of the turpentine wash shown in Step 2, the remaining technique is similar to direct painting shown in Demonstration 7. This process is to finish one area before moving to another rather than developing the painting as a *whole* through the various stages of finish and final completion.

Demonstration

8

Full-Color Transparent Block-in

Step 1. The beginning here actually amounts to an architectural sketch. This is a necessary first step when the subject involves precise, though not necessarily "tight," drawing. In rendering a full-color wash it is important to be as accurate as possible because extensive corrections are bound to diminish the purity of subsequent washes. The composition is a bit unusual in that it contains only a foreground and middleground. The only thing to suggest a "distance" (the fact that there is something beyond the trees) are the few perspective lines of the house. The first brush-strokes are mixtures of yellow ochre, cobalt blue, burnt sienna, and *clean* turpentine. Using a medium filbert brush I paint in most of the horizontal lines of the house. These are easily seen and grasped because the nearly overhead sunlight creates strong cast shadows. While direct sunlight may present problems, drawing is not one of them. The sun is doing all of the hard work for me—the cast shadows alone are enough to graphically describe the house. After painting in the major dark values on the house, I turn my attention to the background values adjoining the house on the left and right. Wherever possible, even at this stage, I am careful to maintain the character of the edges I see. As a final touch I apply a thin wash of viridian and yellow ochre on the right and left as a color note to indicate the foliage that will be painted in during the finishing stages. This color note, however vague, gives me a reference point so I can more accurately judge the color of subsequent washes.

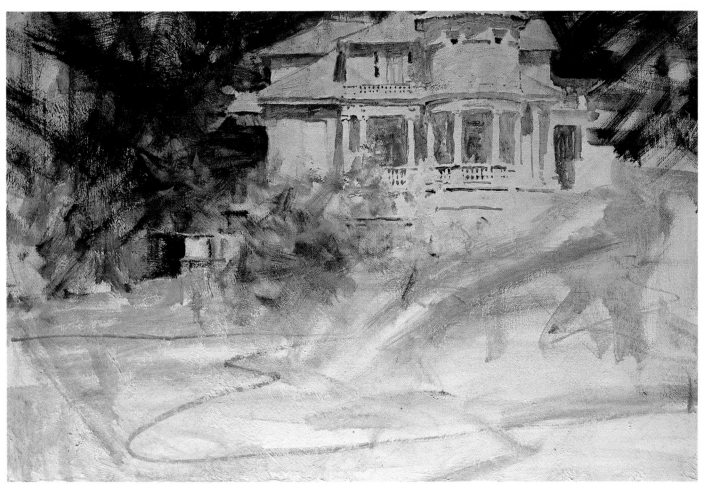

Step 2. At this stage, the transparent color block-in is nearly completed. It is a halfway point in the painting, marking the end of purely transparent paint consistency and the beginning of opaque painting. Viewing the work up to now, it is remarkable how little pigment is actually on the canvas. The total area is 384 sq. inches and there is probably less than half of a gram of paint on the surface. Even without the application of opaque paint that follows, there are already considerable textural qualities present. This is entirely due to the careful way in which the ground of the canvas is applied during the sizing and priming process. It is at times like this that the virtue of homemade grounds is most apparent. Now I begin to broaden the areas surrounding the house, using transparent mixtures of burnt sienna and ivory black. These dark areas to the left and right of the house will remain undisturbed until the last stage of working. They will eventually serve as the deep transparent darks within the trees and brush forming the background. The middle tones are added next— terra rosa and cadmium yellow are applied on the facing walls as a lighter halftone. A few more details of the house are brought out of the left using the same mixtures. Finally, additional green middle tones are somewhat abstractly painted in front of the house. These are mixtures of viridian, cadmium yellow, and burnt sienna. Like the darker tones of the background, they constitute the underpainting, and in the final stages of working will be overpainted with opaque paint becoming more coherent forms.

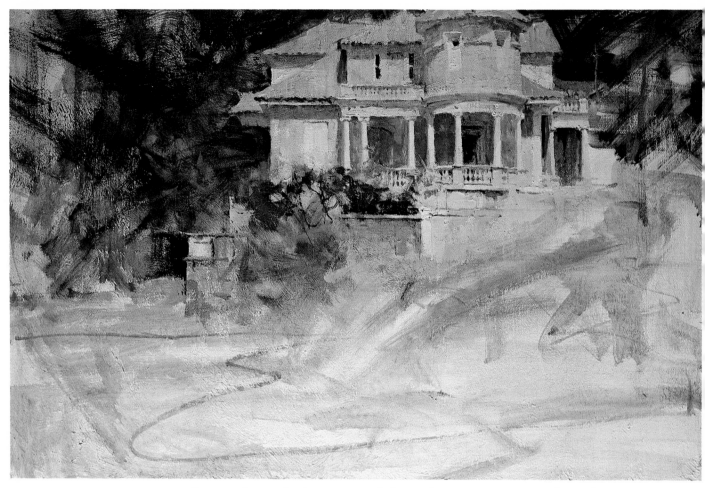

Step 3. This is the beginning of the end—or more accurately—whatever is applied from this point on will not be changed. This is also the frosting on the cake—the most enjoyable state of any painting. All of the hard work is behind me. What remains amounts to a compounding of subtilities, a general enrichment of the existing colors, values, and edges, and of course, the addition of minor details such as the foliage in the foreground and background. The most outstanding feature of this house is the circular facade to the right of center. This is the natural place to begin the finishing process. My concern here is with the way the sunlight gradually slides around the upper portion of the structure, creating a beautifully soft edge. This is done by lightly drybrushing a tone of cadmium yellow, cadmium red, and white on the wall surface and allowing it to extend slightly into the transparent shadow. A few dark accents within the shadow complete the effect. All of the facing walls, the roof areas, and the columns receive a similar drybrushing, using the same mixtures as in the turpentine wash. This time around, however, I add titanium white to the tones instead of turpentine. The next step is to paint in the darker values and accents between the columns. The mixtures are mostly combinations of cobalt blue, terra rosa, and yellow ochre with a touch of white. Continuing on, I select the correct small filbert and sable brushes and paint in the final values and edges on all the columns and balustrades. Finally, using a transparent tone of burnt sienna, ivory black, and viridian, I apply the dark value in the center of the canvas which serves as an underpainting for opaque paint to come.

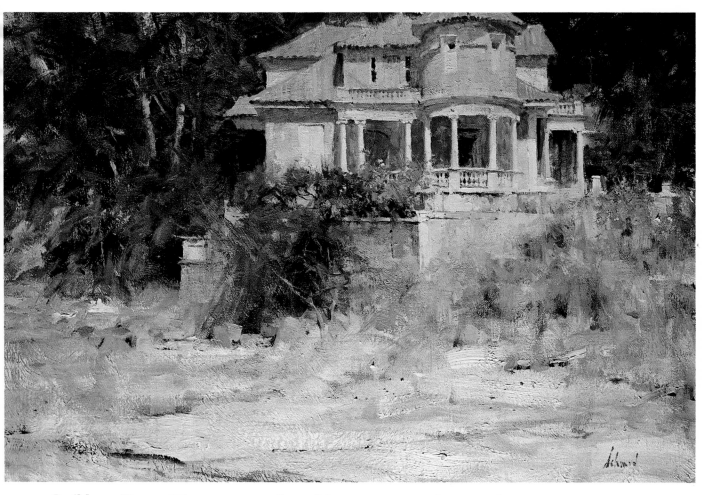

Caribbean House. Oil on canvas, 16″ x 24″ (406mm x 610mm). Except for some minor details and accents, the house was virtually completed in Step 3. From that point on, I will only be concerned with the foreground and background. By comparison to the intricacy and brilliance of the house, they really amount to peripheral areas, although the trees and brush in reality are as interesting as the house itself. So, I want to render them in an interesting but quiet way. The foreground is the least complicated, involving only two steps. First, with a large bristle brush I apply a few random tones. These tones are a high-key turpentine wash, consisting of alternate mixtures of yellow ochre, terra rosa, and cobalt blue. All of them are darker and less colorful than the values on the house. As soon as these values are dry, I overpaint them with horizontal drybrush work and a few impasto strokes using the same brush. The foliage in the middleground and background is rendered in roughly the same way. The preliminary work in these remaining areas was applied in earlier steps. My general approach is usually to paint the complexity of the foliage as an abstraction, using the larger shapes as a guide. Having done this, I paint a few elements within the abstraction in a literal manner. This has the effect of defining the abstract work. The carefully rendered tree trunks on the left, for example, transform the surrounding green paint into tree leaves. Similarly, the few branches visible in the cluster of green fronting the lower left of the house create an unmistakable impression of tropical shrubbery. On the right it is hardly necessary to do more than apply a few light and dark accents to visually explain the area.

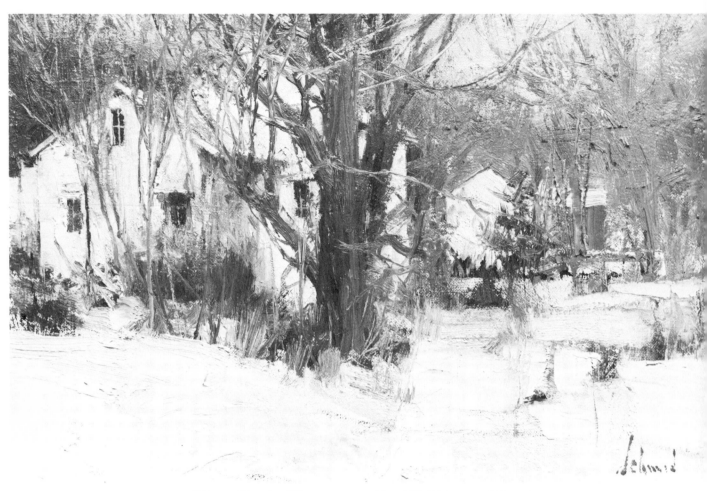

Winter Sketch. Oil on canvas, 8″ x 12″ (203mm x 305mm).

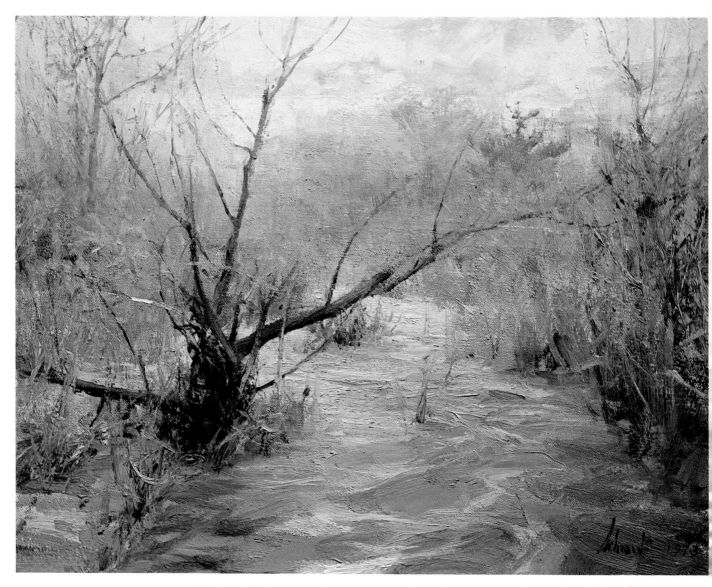

Spring Floodwater. Oil on canvas, 18″ x 14″ (457mm x 356mm). Both the subject and the prevailing light in this painting are similar to those in Demonstration 2. The light is a warm, misty overcast and the subject consists entirely of natural elements. With the exception of the detailed drawing of the tree complex to the left, the painting on the whole is a typical impressionistic rendering. If this does not seem so at first glance, it will be immediately apparent if the painting can be imagined without the tree. This is, in fact, a tree study with an impressionistic landscape surrounding it. The overall color key was set in the very beginning with a thin wash of yellow ochre, terra rosa, and viridian, with the ochre predominating. This was followed by the placement of a few transparent darks to indicate the tree with its outreaching branches. The entire area around the tree was painted in broken color. Finally, I went back to the tree and finished it in detail, taking advantage of the wet underpainting to produce a diversity of edges, from razor-sharp to completely lost. Without this attention to edges, the dramatic spread of the tree branches would be simply a crude silhouette. The edges, more than anything else, integrate the stark lines of the tree with the rest of the painting.

As a painter, only I can be the real judge of my work since I am the only one who knows how close I came to what I set out to do. Good judgment and healthy self-criticism, which are necessary for continual growth, are just other tools in my paintbox. It should be understood that self-criticism, like any other form of criticism, has to be balanced. Self-recrimination is a comfortable state of mind for some artists. I know painters who have something bad to say about their work no matter how successful it is. When I do a good job I must know it and pat myself on the back—and I do.

I must also know when I am in trouble and try to find a solution to my problem. When I was younger, I would either try to fake my way through a problem or I would give up in despair. Every art student knows about those deliciously bohemian hours of self-recrimination, leading nowhere. Perhaps we all must go through this useless state of mind at one time or another. However, I got rid of this bad habit at an early stage. I discovered, with a little prodding, that the only way out of a problem is to find what is wrong and correct it.

I prefer to celebrate my successes, giving credit where credit is due to not only my efforts but to those who have helped and influenced me. Every artist borrows from other artists, not to plagiarize, but to broaden his or her repertoire—like sharing the good news. Of the many artists who influenced me, some of the more conspicuous ones, such as the Impressionists, are known enough not to need mentioning—but there are many relatively obscure, but superb painters who are important to me.

In general, the painting of the late nineteenth century and the turn of the century hold the greatest fascination for me. In America, Innes, Homer, Eakins, and others are familiar names but in my opinion, too little credit is given to John Henry Twachman (1853–1902). It is true that he was an Impressionist but his was a special Impressionism. There is a certain poetry in his work that I do not find in any of the French Impressionists. Perhaps the strongest influence on me is the work of Antonio Mancini (1852–1930). He was not much of a landscape painter. His forte was painting the streets of Naples and particularly the children of the streets. He has unfortunately been characterized as a "fashionable virtuoso." Virtuoso, yes, but hardly fashionable. He painted with the sensitivity and originality of a child until the day he died.

Another painter, Gustav Klimt (1862–1918), is now becoming popular among the cognoscenti. Probably the best of the Art Nouveau painters, his unique sense of composition caused me to reexamine my entire concept of design. Another Italian painter, Giuseppe Casiaro (1863–1945), was a master landscape painter using pastel, one of the most difficult of mediums. His sense of color and free style are unmatched by any painter. He is the only artist I know of who came close to capturing the Mediterranean light. There are many others: a Czech painter named Frantisek Kavan, a Russian named Serov, and Max Liebermann, Nicoli Fechin, John Constable. The list goes on and on as a quiet litany in my personal life.

I feel at home with painters who paint for the simple love of celebrating creation rather than a concern for making their niche in the history of art. Any painter of worth is naturally aware of his own voice in painting, but his or her ideas are not mutually exclusive. In fact, they amount to a concomitant homage to what Robert Henri refers to as the "brotherhood"—the unbroken line of individuals who paint for the sole purpose of magnifying the privilege of being alive.

The following group of paintings is presented as a cross-section of subjects and techniques in my outdoor work. The collection is by no means exhaustive; there are no watercolors for example. Occasionally I do a landscape in watercolor but generally I feel more at home with oil paint. It must be said, however, that the differences between watercolor, oil, pastel, or acrylic are purely technical and the basic elements of color, value, drawing, and edges are the same for all of them. I have excluded acrylic painting also because it is not a medium I often use. When acrylics first appeared they were offered as a universal medium possessing the good qualities of watercolor, oil, and casein without any of the drawbacks. Experience has shown that this is not the case. The polymer colors are not a substitute for anything. They have their own working properties that constitute an entirely new system.

One final note about this gallery section. I found it particularly difficult to describe many of the paintings reproduced in black and white because color is such a dominant element in my work. Many of the descriptions that follow will deal with considerations other than color. While color is important, in most of the paintings it was not always the main problem, particularly when painting in public. In every case, I have tried to convey not only my procedures, but my feelings about the subject prior to the start of painting and during the course of working. Although the comments about each painting are brief, taken together they say quite a lot about landscape painting in general and *seeing* in particular. And as I pointed out in the introduction, *seeing* is what it is all about.

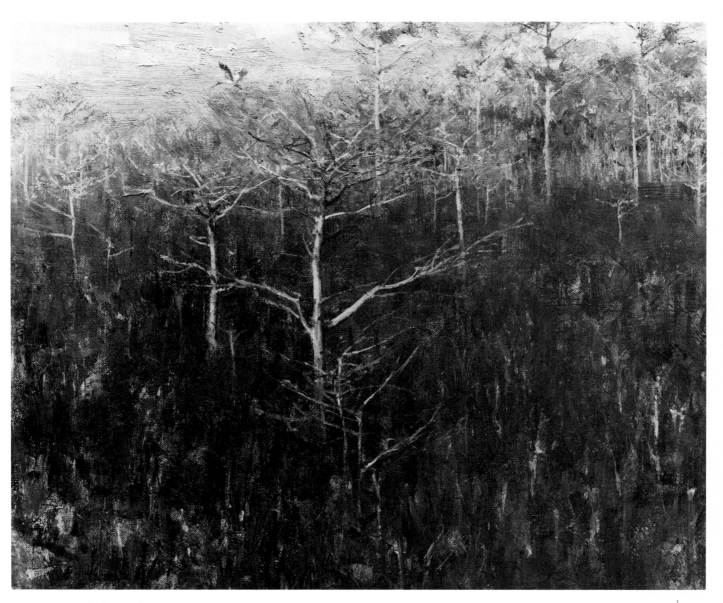

Everglades. Oil on canvas, 16″ x 20″ (406mm x 508mm). I suppose everyone who visits the Florida Everglades for the first time without knowing what to expect is surprised. Entering the "Glades" by car, I fully expected to be instantly plunged into a tropical forest. Instead, I found myself in the midst of an enormous saw-grass prairie as flat as any Kansas wheatfield, broken only by occasional groves or "hammocks" of mahogany and pine trees. The area, of course, is teeming with life, but in that vast prairie the overwhelming impression is emptiness. The problem was: how to paint emptiness. The answer was not to even try. The landscape is so plain and bland that even a modest group of small saplings stand out like flagpoles, so I made one little tree, hardly five feet high, the prime focal point. In the distance there was a sparse stand of pines that conveniently broke up an otherwise flat sky. The block-in and finishing technique was roughly the same as the impressionistic method shown in Demonstration 2. In all situations where the subject as a whole is extremely plain, I always search for some detail to act both as a contrast to the larger masses and an enhancement. A small bird on a beach, for example, can make ordinary breakers look like tidal waves. There are more possibilities in every scene than one would expect at first glance.

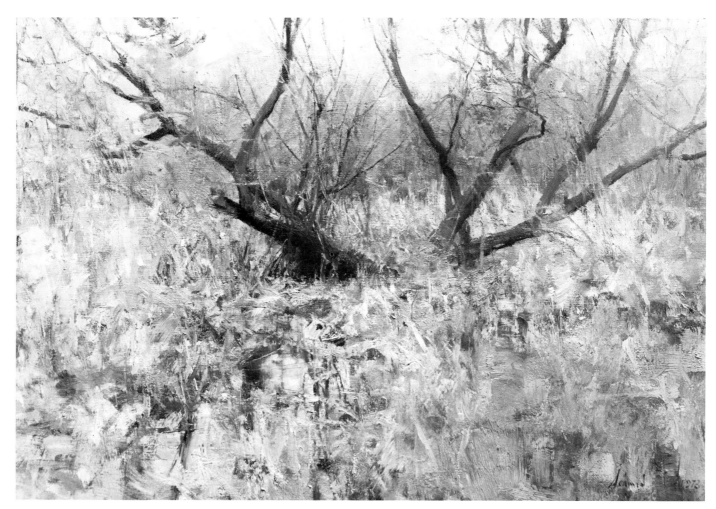

Spring Willow. Oil on canvas, 20″ x 30″ (505mm x 762mm). This beautiful black willow is one of many that grace a swamp near my studio. It was painted in early April before any leaves had appeared. Ordinarily, this time of year is a relatively bleak period. The trees are bare, the sky often gray and the ground cover a mixture of grays and browns—the leftovers of winter. This was a beautiful exception. The ground was covered with the golden-colored remains of cattails, skunk cabbage, and swampgrass in standing water that reflected all the color. The bright sunlight was diffused through a morning haze further enhancing the color. The situation was identical with the tree study "Spring Floodwater" on p. 112. The composition and canvas size are different but the problem is the same—a carefully drawn portrait of a tree surrounded by an impressionistic landscape. There were actually two separate techniques used in this painting, but the light as well as the careful use of edges combined to integrate the painting. I began with a transparent wash of terra rosa and yellow ochre to establish the overall color key. The dominant trunks and branches of the willow were then painted with a darker transparent tone of viridian and burnt sienna. The dark value under the willow trunk just to the left of center was also placed at this time. This is the most important dark and the sooner it gets on the canvas, the better. The next stage was to completely paint all of the areas behind with willow using broken color and drybrushing. The tree itself was carefully painted and worked into the impressionistic background. The shape and value of the tree are important, of course, but the edges are what make it part of the painting. The foreground has a good deal of heavy paint on it but the edges and values are relatively close so the area remains quiet but explained, almost as a foil for the tree.

San Margherita Harbor. Oil on canvas, 14″ x 18″ (356mm x 457mm). San Margherita is one of those "picture book" villages that dots the coastline of the Italian Riviera. Time was very short for painting and this scene in particular required the fastest possible technique—direct painting—with almost no attention to detail. It was a late April day close to sunset and the lights and shadows were moving much too rapidly for a more extended study. Moreover, in spite of the fact that I had situated myself at the far end of a pier for privacy, a large crowd gradually materialized so I wanted to get it over and done with. Italians, besides being among the friendliest people on earth, are also insatiably curious about artists. I proceeded to paint with finished color from the start—first the darks and lights across the upper half of the canvas, working out the broad areas and more important architectural features. Next, the halftones in the sky and distant hills were painted. The broad middle tone running across the entire center was then painted followed by the values in the foreground. As a last touch, a few lights were added where the sun was striking the tops of the ships' masts.

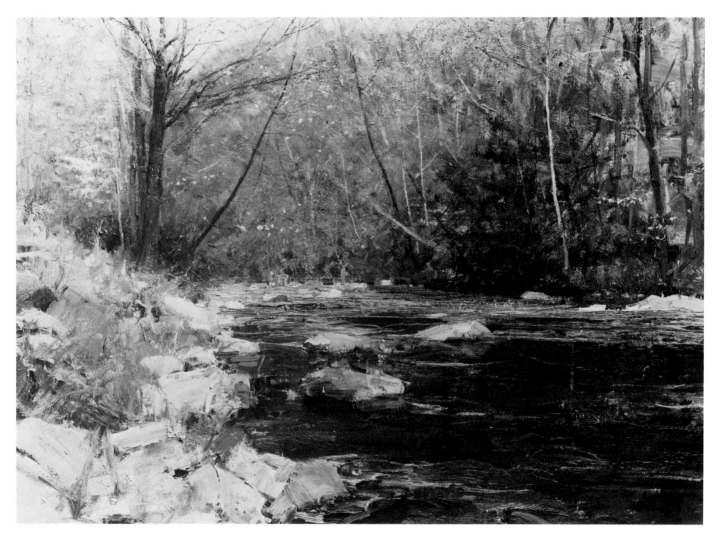

Cataloochie Creek. Oil on canvas, 24″ x 32″ (610mm x 813mm). The Great Smoky Mountains in western North Carolina abound with majestic scenery as well as tourists. People traveling to see the Smokys pass through landscapes on the way that are just as beautiful. This creek is one of hundreds in the area, each one quietly beautiful. I painted this in the springtime when the first leaves appeared and the flowering dogwood was in full bloom. I selected a large canvas because there was ample painting time and I wanted to include more detail than a smaller canvas would allow. The painting began with a transparent wash of viridian and yellow ochre to establish the color key. Using small bristle brushes, I worked into the wash in the upper half of the canvas with broken color. The background was varied in color, creating a delicate, impressionistic setting. The large tree on the left was painted over this background as well as the smaller trees on the right. The entire upper half of the canvas was worked and reworked with a palette knife, drybrushing, and broken color until everything blended with everything else—with a few trees and light and dark accents standing out. The river and the river bank on the left—the whole foreground, in fact—was finished with palette knife painting and some minor drybrush painting.

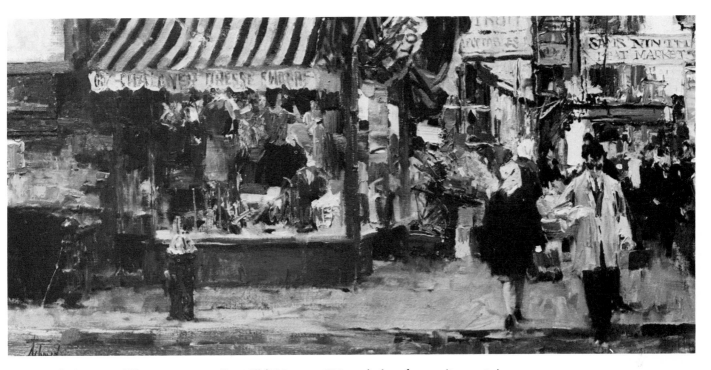

9th Avenue. Oil on canvas, 12″ x 20″ (305mm x 508mm). Any large city contains an endless array of subject matter, depending upon the mood of the observer. It can be depressing, confusing, invigorating, dreary—the possibilities are endless. I suppose most people experience most of these diverse feelings about New York, because the sheer size and complexity of it is overwhelming. Ask any former mayor. I have felt many different ways about New York, but as a painter, one of them keeps repeating itself. Whatever its problems, New York, particularly Manhattan, is a kaleidoscope of continuously changing colors and patterns—an endless visual delight. Expressing this on canvas from life is no easy matter, especially on a busy street at midday. It requires extraordinary concentration, nerve, and a lot of experience because of the many possibilities of interference and distraction. Painting is difficult enough without worrying about being hit by a truck or arrested for unlawful assembly. Having decided what I wanted to paint, the next problem was finding a spot to set up a canvas. Fortunately, there was a relatively inconspicuous nook between a service pole and a newspaper stand on the sidewalk opposite this scene. I had a good view, working room, and as much privacy as one could expect on a midtown street. My canvas was already prepared with a transparent wash of cobalt blue and yellow ochre because I had walked the area the day before and I knew from forecasts that the light would be the same. I followed the same general sequence of direct painting described in Demonstration 7. The problem was essentially the same though somewhat more abstract. The darks were first applied to establish a definite value pattern. Over the darks, the lighter and more colorful halftones and middle tones were painted. Finally, I selected a few figures for inclusion in the right foreground. The final touches were done in the studio; these involved only minor adjustments of edges and light and dark accents. This painting, like the others shown in monochrome, is a study in brilliant colors and cannot be described adequately as a black and white reproduction—but the final effect, in some degree, speaks for itself.

Victorian House. Oil on canvas, 18" x 24" (457mm x 610mm). The unusually high contrast in this picture is partly because a black and white negative had to be made from a color transparency and some of the more subtle middle tones were lost in the process. However, the scene was one of high contrast to begin with—an almost pure white house outlined against dark conifers. It is almost a reverse silhouette. It was a late afternoon in September and the painting time was limited to less than two hours, so I proceeded with a direct painting technique after a brief block-in. The block-in was very simple, involving a few lines to place the house accurately, followed by a dark transparent wash of burnt sienna and viridian in the area of the pine trees and another transparent middle tone of yellow ochre and cobalt blue for the foreground. This was more than enough to get started with the finishing work. I began with the house, painting the light value on the roof and the light halftone on the facing wall. Next, the darks under the eaves, the windows, and the porch were painted with small bristle brushes and a palette knife. Many of the background darks were painted at the same time so that the appropriate edges could be created, particularly under the porch. With the house nearly complete, the large spruce tree on the right was painted with dark green tones of viridian and burnt sienna. Again, special attention was given to the edges of the tree, especially the left edges where it mingles with the values of the house. The foreground was completed with palette knife and dry-brush painting. The horse was an afterthought. I needed a light spot on the left to create a secondary interest, so I painted the horse in from imagination.

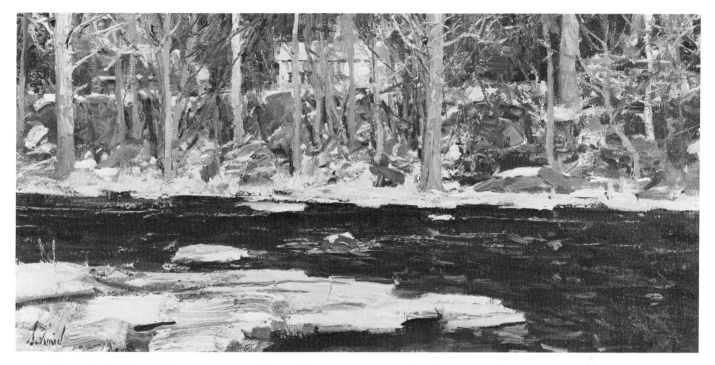

Housatonic River. Oil on canvas, 14″ x 30″ (356mm x 762mm). This is another example of how to violate the so-called "rules" of composition. Notice how the canvas is neatly divided into equal halves by the horizontal line of the river bank. I am not particularly concerned about it. The intention of the "rule" forbidding lines in the exact center of a canvas is to avoid having two separate paintings on one canvas, but no such thing happened here. While the canvas is indeed equally bisected, it is still a homogeneous composition. There is simply not enough interest in the lower half to compete with the upper part. The broad, simple masses of the water and ice in the foreground lead the eye naturally upward to the more complex painting on the far river bank. The illumination in this scene is clear, direct sunlight, coming in from behind me and slightly to the right, producing crisp, high contrast value relationships and brilliant color. There was a deep blue sky, enriching all of the cast shadows and causing the river to take on a dark ultramarine blue almost straight from the tube. Wherever the snow received direct sun, the mixture was titanium white with a slight touch of cadmium yellow for warmth. There was very little in the way of a block-in— merely a light transparent wash of yellow ochre and cadmium scarlet. With this tone as a color key, I immediately went into direct painting, starting with the deep blue of the river. This was painted quickly and vigorously with impasto brushing and palette knifework. Against this, the white of the snow on the river bank was applied. This gave me a convenient set of values that made it easier to judge the remaining colors. Before painting the dominant row of trees along the river bank, it was necessary to do some preliminary painting in the form of broken color and drybrushing. Into this the trees were painted, working in steps painting the farthest trees first and working forward to the main row at the water's edge.

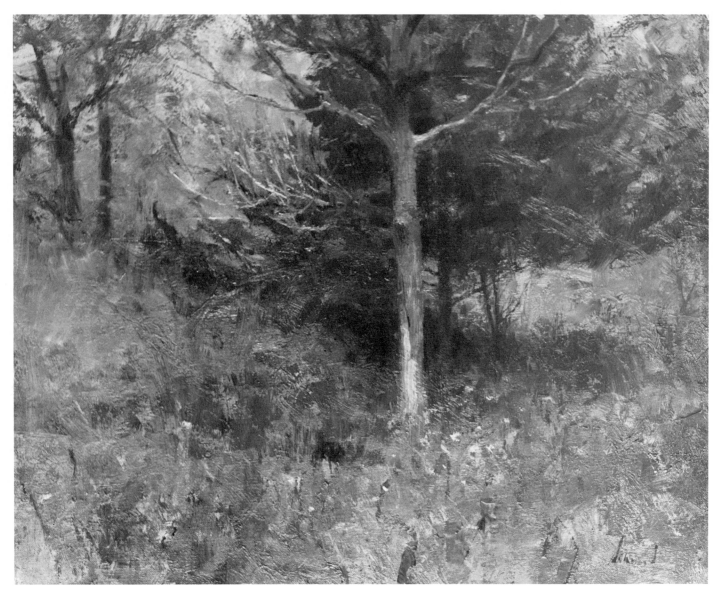

Spring Oak. Oil on canvas, 18″ x 14″ (457mm x 356mm). Often in summer, painters encounter the kind of color that makes them want to go home and wait for autumn to arrive. However, although a scene may be predominately in the green family, there will also be reds, yellows, blues, oranges, purples, etc. The overcast light here was steady and I had ample painting time, so I began with a full-color turpentine wash. This was a natural choice because of the prevalence of darks in the upper half of the canvas; a thin wash of color minimized glare in that area. The full-color block-in also lessened the overpainting in peripheral areas so more time could be devoted to the main statement, namely, the powerful stance of the oak in the center against the brooding darks of the conifers behind it. After completion of the transparent block-in, the entire background area was brought to a state of completion before any final work was attempted on the oak. The brushwork in the background is an interplay of broken color, drybrushing, and transparent tones. Against this background I painted the oak from the ground up, alternating with a palette knife and a small filbert brush. The oak was finished with impasto strokes, creating a strong feeling of three-dimensionality.

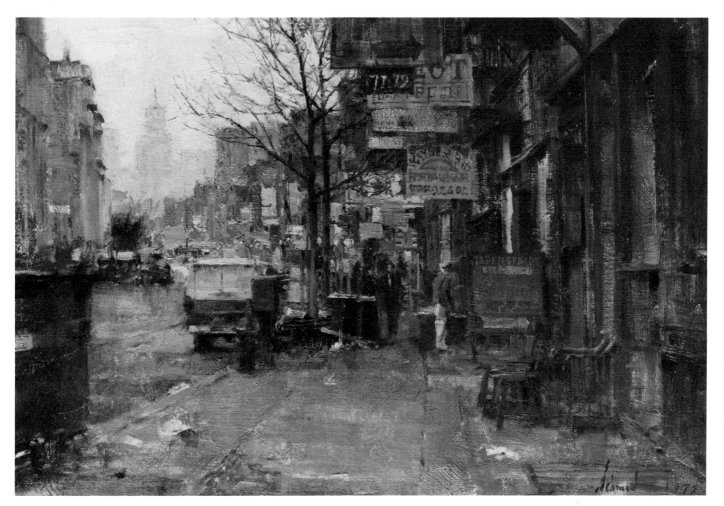

Lower Manhattan Street. Oil on canvas, 24″ x 16″ (610mm x 406mm). Painting on the streets is not an easy task, particularly for a novice, but one must begin somewhere. Fortunately, I began painting in public when I was young enough not to be self-conscious. After many years of painting on the streets of Chicago, New York, Florence, Rome, and Caracas, I have found that no matter how inconspicuous I try to be, an audience of the curious and critical will inevitably gather. So, street painting requires a thick skin. Aside from crowd control, however, the painting itself proceeds much the same as any other landscape painting. This study of the Bowery area in Manhattan followed the same general development as the street scene in Demonstration 7. I began by toning the canvas with a light turpentine wash of cobalt blue and burnt sienna. While this was drying, several lines were painted with a small bristle brush to establish the all-important perspective lines. This must be the first step in a scene like this because uncertain corrections in perspective at later stages of the painting could be disastrous. With the vanishing points and lines correctly placed, I began the painting in almost the exact center of the canvas and finished that area before moving on. The sequence was to paint the area in "layers," *i.e.*, the distance first, then the middle distance, the middleground, and finally the foreground. When a subject presents as many overlapping geometrical shapes as this, starting with the distance and working forward is the best method of achieving good edges. I worked outward in all directions from the center, using the same layered approach.

Monday. Oil on canvas, 12″ x 24″ (305mm x 610mm). I am a connoisseur of clotheslines. There is no denying it. There is nothing quite like lines of brilliantly colored laundry strung out in full sunshine. I can remember washdays in Chicago when I was just a child. From my own backyard I could look down on all of the other backyards for two blocks around and the sight was a splendid abstraction in pure color. Progress, in the form of the clothes dryer, has changed that somewhat, but clotheslines can still be found. Not everyone has a dryer and even among those who do, there are some die-hards. Not the least of life's little pleasures are clean sheets dried in sunshine. Some people are more imaginative than others in hanging a line of wash. Some are downright artistic, probably without knowing it. I do not mean to rhapsodize so much about laundry, but it is just that in landscape painting there is rarely a chance to apply pure colors straight from the tube without creating a garish effect. What painter has not gazed at his palette and wished it was unnecessary to spoil all those nice, clean primary colors by mixing them together? Another delight in painting a clothesline is that it provides an opportunity for a palette knife *tour de force*, since many of the larger shapes on the clothesline can be painted in one clean stroke. I began this painting with a transparent wash of viridian and yellow ochre. Over this, I drew a few lines to help place the house and the barn at the extreme right. Next, the solid mass of the background trees was painted using a large bristle brush with mixtures of burnt sienna, viridian, and yellow ochre for the middle values, and ivory black and burnt sienna for the darkest darks. The house was finished with smaller brushes. The facing walls of both the house and the barn were painted with impasto palette knife strokes. Finally, I arrived at the clothesline and painted it starting in the center, then working outward to the left and right. It was like decorating a Christmas tree. The two sycamore trees were added on the left and the foreground was finished with transparent washes and drybrush painting.

Mule Deer. Oil on canvas, 12" x 24" (305mm x 610mm). These three deer were part of a larger group I came upon in the beautiful northern rain forest in Washington State. Placing wild animals in a painting is a delicate matter. The problem is one of taste as well as credibility. Few animals in the wild will be obliging enough to pose unless they are asleep or observed from a distance so that they will not detect human presence. Lions and tigers, for example, can sleep for hours or just lie around staring into space. Most animals will either flee or attack when they are discovered. One thing is certain—all wild animals are unpredictable, including those normally considered benign. I have been attacked, without provocation, by such seemingly innocent creatures as seagulls, deer, woodchucks, and red-winged blackbirds. In every case my assailants were female and I was probably close to their nest or their young. This group of mule deer were unusually docile. There were about twenty-five in the herd and I was able to walk slowly in their midst, close enough to touch them. I was working with a Hasselblad camera and the shutter release made quite a racket. This seemed to be the only thing that bothered them. This painting was the result of one of those photos. I had done other sketches from life in the area and I have studied deer in the zoo and even from my studio window, so putting it all together was no problem. The secret is a working knowledge of comparative anatomy and animal behavior. The painting began with a rich transparent wash of viridian and cadmium yellow. The illumination in this picture was diffused sunlight and nearly everything in the rain forest is covered with a warm green moss. Green light permeated everything, including the deer. Their normally gray-brown coats looked like they too were moss-covered. After the transparent wash had dried, I painted the middle tones in all three deer and then applied broken color throughout the canvas. All of the mixtures were either in or related to the yellow-green family. With all of this color in place, I painted in just enough detail to bring out a few trees. Finally, I applied a few light and dark accents to the deer—just enough to define them without causing them to stand out. Since the light in this painting was more important than the deer, they had to merge into it along with the trees and other elements.

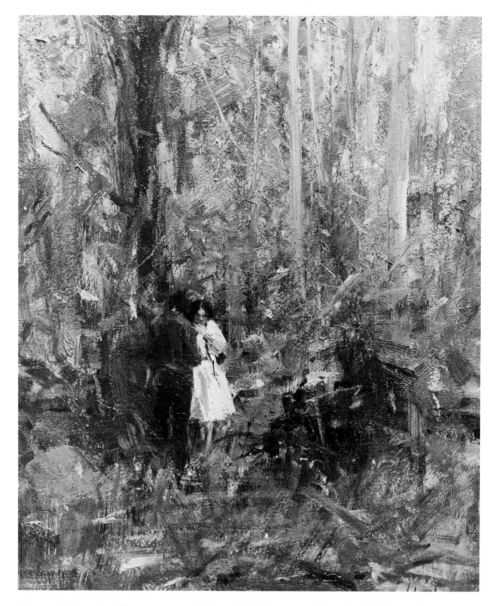

Happy's Forest. Oil on canvas, 14″ x 18″ (356mm x 457mm). This is an interesting problem in taste as well as in technique. The situation is one of obvious intimacy and my task was to convey this without overdoing it. It would be easy to become so preoccupied with the figures that the work would degenerate into one of those silly melodramatic settings that characterized Victorian painting. It could also easily slide into the category of illustration. I have nothing against either Victorian painting or illustration, but it is my intent here not to tell a story but rather to convey a subtle and very private moment—nothing more. The natural approach then was to render the figures in the same loose manner as the surrounding forest while maintaining their dominance by reserving for them the strongest color, value, and edge relationships. With this clearly in mind, I began the sketch with an overall tone of viridian, cadmium yellow, and burnt sienna applied as a middle-tone turpentine wash. Over this unifying tone I applied random strokes of transparent green mixtures to represent the background foliage. While this was still wet I painted the light tree trunks in the center and right with a medium bristle brush, using opaque paint. The dark tree on the left was painted in the same way. The white of the girl's dress was next applied with a palette knife and then corrected with a small bristle brush. Finally, the figure of the boy and the head and left hand of the girl were loosely painted in. The foreground was finished with a few drybrush strokes.

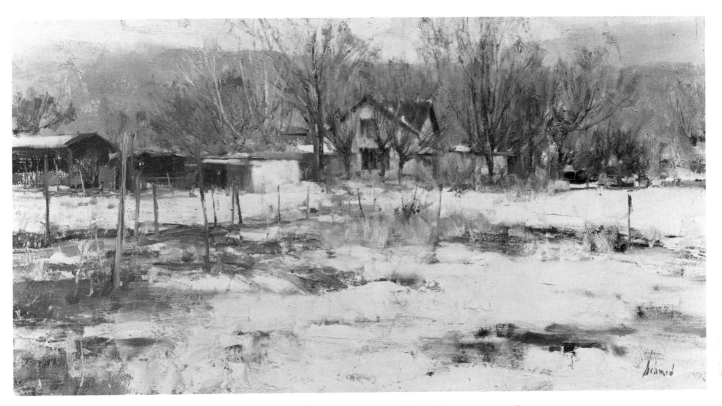

Taos Farmhouse. Oil on canvas, 30″ x 16″ (762mm x 406mm). This is an unusual house for Taos, New Mexico, because most of the older adobe structures have flat roofs. The interesting diagonals of the peaked roofs in the center were the main reason I chose to make the farmhouse the center of interest. The light was steady—a high, bright overcast—and being early spring, the day provided ample working time. Another unusual aspect of this painting is the prevalent aerial perspective. The Sangre de Cristo Range in the distance is marked by distinct value changes as it recedes. This is not generally characteristic of the mountains in the western United States because the average altitude at their base is relatively high. In Taos it is about 8,000 feet. The rarefied air at these altitudes is usually crystal clear, causing distant mountains to appear deceptively close. So much for the scene—the painting itself is, more than anything else, a study in edges. The only brushing technique not extensively used was drybrushing. The block-in was similar to the opaque and transparent approach described in Demonstration 3. I began by toning the entire canvas with a semi-opaque mixture of cobalt blue, yellow ochre, and white—a value and color similar to the one used in the sky in the finished version above. In extremely cold conditions such as this, oil paint "sets" rapidly (the viscosity of linseed oil decreases as the temperature drops), so I had not long to wait before working into this tone. I proceeded to work in "layers" from the distance to the foreground. The distant mountains were first painted with broad, horizontal strokes using a large, flat bristle brush. Next, the background trees were painted, and over this the farm buildings. Continuing forward, the trees in front of and flanking the farmhouse were very carefully painted, using a palette knife, a small filbert, and a small, round sable brush. Finally, the foreground was applied almost entirely with a large palette knife. This, briefly, was the sequence. This order was by no means rigidly followed. There was a good deal of working back and forth between foreground, middleground, and distance; otherwise many of the edges in this finished stage could not have been achieved, particularly in the center.

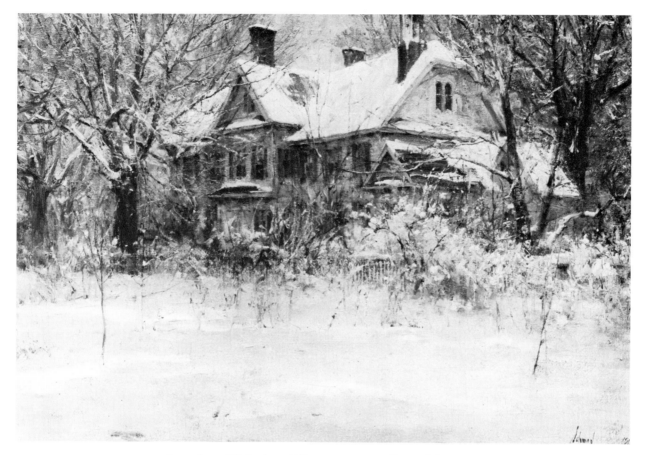

American Victorian. Oil on canvas, 24″ x 36″ (610mm x 914mm). This remarkable old house in considered to be one of the finest authentic examples of American Victorian architecture in New England. I have painted this house several times, partly because it is a fascinating structure, but more importantly, because time and the seasons have combined to present a larger setting of ever-changing effects. The principal effect is that the house seems to have an organic character—almost as if it had grown up with the surrounding trees. Here, as in other paintings containing subjects of intrinsic charm, it is imperative to maintain a concept of the painting as a whole and not dwell excessively on the center of attraction. In this case, for example, I am not showing the observer what a pretty piece of nostalgia the house represents. Of course it is beautiful—it speaks for itself. To emphasize the fact would be gilding the lily in the worst way. The house, as far as I am concerned, is merely the dominant object in a larger statement. The message here is about a mood of winter, with the brooding mass of the house interacting with the sky, trees, bushes, snow, and light to convey this message. A heavy, wet snow fell the night before this study was done. Everything seemed to be bending under its weight. In order to complete so large a canvas in the time available, I chose to begin with an opaque and transparent block-in as described in Demonstrations 3 and 4. One of the advantages of this method is that a large percentage of the block-in can remain untouched in the later stages of the painting, provided it is done carefully. The color and light were both low-keyed, making this more of a value study than anything else. After applying an initial tone (about the value in the sky), I drew in most of the darks under the eaves of the roof complex. This firmly established the house. I went on to paint the principal value masses—the lightest light on the snow-covered roof, the darks in the trees, the middle tone on the side of the house, and the light halftone in the foreground snow. The painting was then finished in the same general sequence shown in Demonstrations 3 and 4.

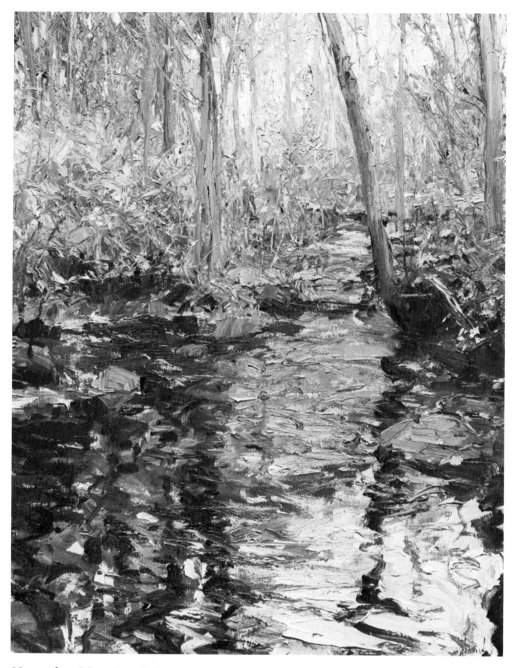

November Morning. Oil on canvas, 24″ x 30″ (610mm x 762mm). In Demonstration 2 I described one method of the impressionistic approach. This is a similar problem, but there are important differences. The canvas area is three times larger, the foreground is a small pond in a constant state of rippling motion, and the painting time was somewhat limited. The approach had to be both fast and accurate. This always means there will be less interest in detail and greater emphasis on color. The result here, in spite of the difference in size, is a much looser, more heavily painted canvas. The majority of the canvas is painted in impasto broken color in the classic Impressionistic tradition. After saturating the entire canvas with a rich tone of pure cadmium yellow, I began to apply broken color with a palette knife and a medium filbert brush in all areas of the canvas. The sequence was to bring the entire canvas to equal stages of completion rather than concentrating on any single spot. When it reached the degree of finish I wanted, it was only necessary to add a few dark accents to the dominant trees in the center to complete the work.

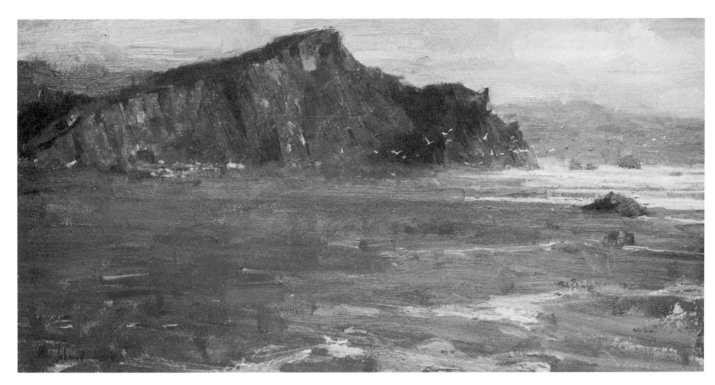

North Pacific Coast. Oil on canvas, 16″ x 32″ (406mm x 813mm). This painting presented none of the problems of movement normally encountered in a seascape. The task here was to express the vastness of the Pacific beach in the fading light of evening. My working time was very short, so after a preliminary wash of cobalt blue and yellow ochre, I went right into direct painting. The starting point was the dominant land mass in the middleground. There was very little detail to worry about, so the finishing process was a relatively simple matter of painting in the remaining value masses.

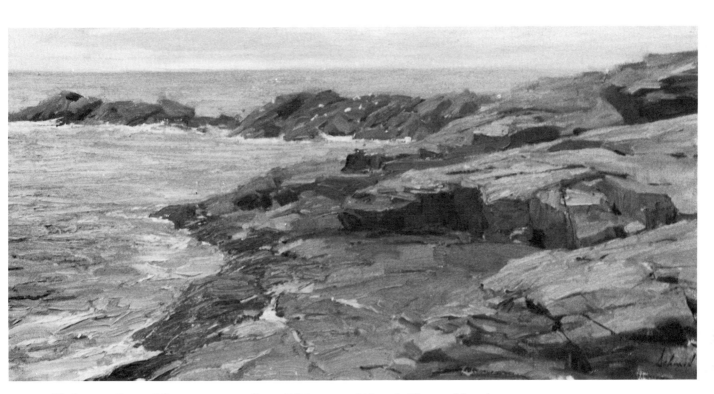

Christmas Cove. Oil on canvas, 12″ x 24″ (305mm x 610mm). The problem here is exactly the opposite of the Pacific Coast study and is really a study of rock formations touched by a gentle sea. This is another sketch along the southeastern end of Monhegan Island. The giant slabs of rock were a challenge because of their abstract shapes and absence of a conspicuous focal point. To overcome this, I sharpened the edges of the central group of rocks and subdued all others. It would be fair to say that the emptiness of the site is the real subject of the painting.

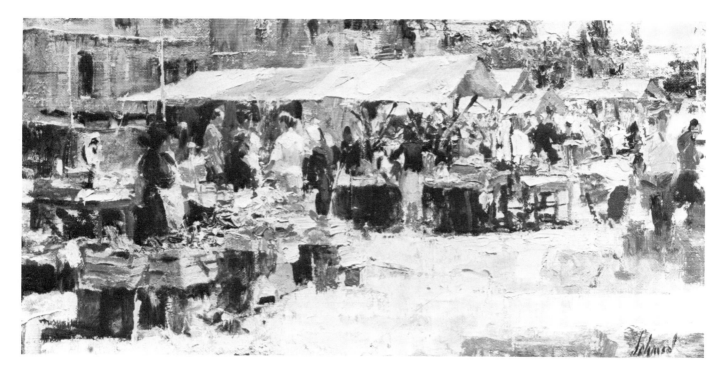

Siena Market. Oil on canvas, 8″ x 16″ (203mm x 406mm). The town of Siena in the Tuscany region of Italy is one of the great cultural centers of Europe. It is filled with lovely thirteenth and fourteenth century architecture. Most people are attracted to Siena's classic sights, but there is more there than one would expect. Behind the famous Piazza del Campo, for example, is the open air market shown above. With all of its teeming color under the Mediterranean sun, it rivals anything else in Siena. It was about midday when I set up my easel and since no one seemed to notice me, I was able to concentrate and work quickly. I chose a small, light-textured canvas for this sketch for two reasons. First, I wanted to avoid involvement with excessive detail—something that would inevitably occur with a larger canvas. Second, in Siena as in many other parts of the world, everything closes down in the afternoon to reopen later. So I had only about an hour before my subjects all went home for lunch and a nap. I had already given the canvas a warm transparent wash of yellow ochre, so there was virtually no preliminary work other than the placement of a few lines and values as guides. The first of these outlined the awning that dominates the center of the canvas. A few transparent darks of ultramarine blue and burnt sienna were painted beneath the awning and in the left foreground. These few darks were all that was necessary before I proceeded with direct painting. The general sequence was a concentration of work in the center area to more or less establish the degree of finish—followed by the same brush and knife painting, working toward the right and left. The majority of this sketch was done with a palette knife. It is conspicuous just about everywhere on the canvas. This was a stimulating experience for me because one of the main reasons for going to Italy was to study the original work of the nineteenth century Italian painters. Painting under the same light gave me an insight into their work that could not have been obtained otherwise.

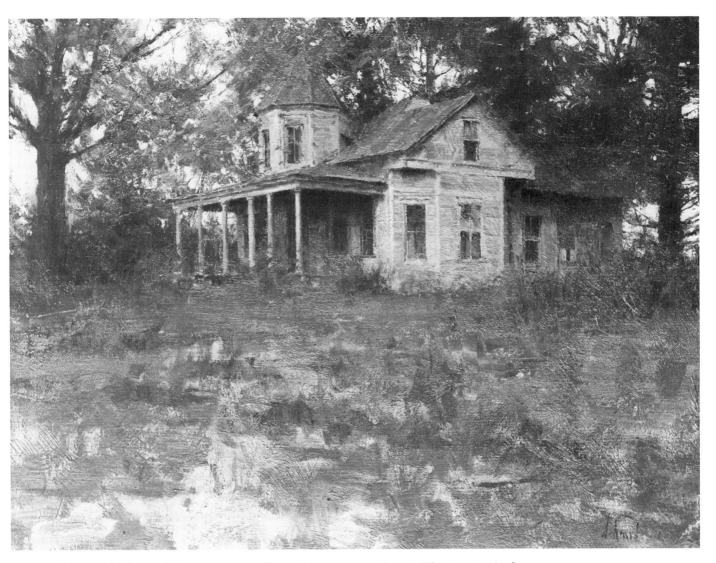

Clapboard House. Oil on canvas, 18″ x 24″ (457mm x 610mm). This is a typical problem in open shade. The old house, only one of many I painted in the Midwest, was almost completely surrounded by enormous trees. The prevailing light was cool, except for one small patch of sunlight striking the column of the right corner of the porch. The roof of the house had a rusty tin surface that had once been painted red. All in all, it was a brilliant display of color. What made this so striking in color is the fact that complementary colors and strong contrasting values interact to transform what otherwise might be a rather moribund structure into a rich color display. There was quite a lot of drawing involved in the house. Besides being a color study, the house itself had interesting form, so I chose to begin with a full-color turpentine wash. This ensured not only accurate drawing in the house, but accurate color throughout the painting. It also considerably reduced the amount of time spent in the finishing process. In all respects the procedure was identical to that shown in Demonstration 8. The only real problem was the cool light on my canvas reflected from the clear sky behind me. I corrected this as I went along by increasing slightly the coolness of the green mixtures in the painting.

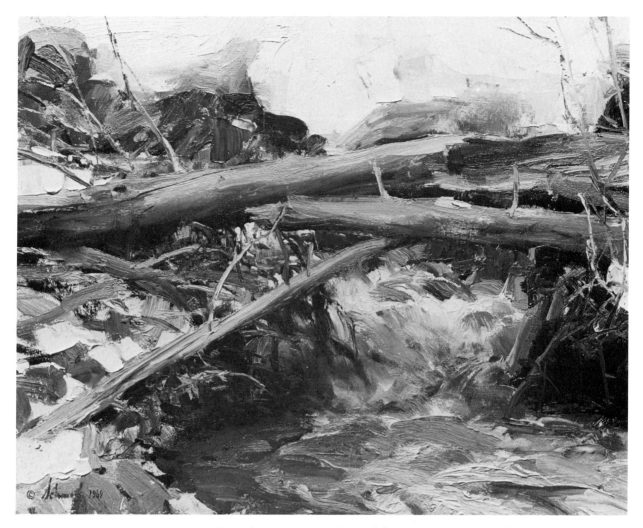

Rio Hondo. Oil on canvas, 12″ x 16″ (305mm x 400mm). The Rio Hondo is one of the many brooks that originate in the Sangre de Cristo Range in northern New Mexico. This one is particularly beautiful as it wanders through Hondo Canyon and eventually empties into the Rio Grande south of Taos. It has been painted by generations of artists because of its proximity to Taos, which has been an art colony for a long time. I first sketched the Rio Hondo in 1958 and I have returned many times, in all seasons, to paint it again. This sketch was done in the spring of 1969. The altitude at the location was almost 9,000 feet and there was still a thick blanket of snow that was slowly melting, swelling the brook. This is hardly a landscape in the usual sense. It is more of a close-up study of a few fallen aspen and fir logs. There is a snow bank at the top of the canvas and a brook, rushing through a gap only a yard wide, beneath the logs. There was no preliminary work whatsoever. Time was short and it was extremely cold, so I wanted to paint as fast as accuracy would allow and retreat to the warmth of Taos. Naturally, I went right into direct painting. The canvas was small, so the first paint applied was an impasto palette knife stroke done in one swipe across the entire upper half of the canvas. I corrected the lower edge of this off-white value with a medium bristle brush and a palette knife. This completed the snow bank. Next, I made three heavy strokes across the center of the canvas and softened some of the edges, which completed the logs. Finally, with a palette knife and small brushes, I applied broken color throughout the lower half of the canvas, finishing the brook and the left bank of the stream. A few final accents and edge corrections brought the entire sketch to completion.

Ozark Pasture. Oil on canvas, 22″ x 28″ (559mm x 711mm). The Ozark Mountains in northern Arkansas are not much different from the hills of Connecticut where I have my studio, so I had my eye out for something I would not ordinarily see in my own backyard. Not too many people in my neighborhood keep goats or sheep or whatever these creatures are. When I came upon these animals—the curious two in the background and the impassive character in the foreground absorbed in his grazing—I could not resist a few sketches. Unlike wild animals, these sheep (let us call them that) remained still for long periods of time, so I was able to make numerous sketches and photos and combine the material into a large canvas in my studio. I did not want to attempt a large canvas on the spot because there was always the chance that one or another of the animals would move at a critical moment, leaving me with a white blob on the canvas where a sheep should be. Working in the studio, I had all the working time I could possibly need. This can sometimes be a disadvantage because the temptation is ever-present to relax and work everything out to the most minute detail. To avoid this, I set a time limit equal to what it would ordinarily be if I were working in the field. This naturally forces a more painterly result than would ordinarily occur in studio work. As for the actual painting technique, I proceeded along lines identical with the standard block-in described in the first demonstration.

Ranchos de Taos. Oil on canvas, 12″ x 24″ (305mm x 610mm). This was an extremely fast sketch lasting hardly more than half an hour. Ranchos de Taos is a small village south of Taos, New Mexico. It is still a place relatively unchanged by progress, although I am sure its days are probably numbered. Most of the buildings of the town are adobe structures and the adobe color blends perfectly into the color of the ground surface. Even those houses that have been painted or covered with cement take on the color of the soil. This is because rainstorms and duststorms, which blow up from the desert to the south, often occur simultaneously, coating everything with a fine layer of mud, making everything the same color. Nature is very obliging in providing such a natural harmony. This sketch was started just as such a storm had passed. The remnants of the clouds can be seen in the upper right of the canvas, obscuring the distant mountain range. I used the tone of the adobe color as the first transparent wash on the canvas. It is a light halftone consisting of terra rosa, yellow ochre (predominating), and cobalt blue. The actual painting process was hardly more than adding some lighter and darker values of the same mixture, with slight temperature changes (the predominance of cobalt blue in the sky, for example). Finally, some light and dark accents finished the sketch. The dark accents occur under the eaves and on the roofs of some of the buildings, including the twin steeples on the historic church to the right of center. On the left a strong light accent was applied to the gable end of a house with a heavy palette knife stroke. I decided to stop at this point even though there was enough subject matter before me to keep on painting for hours. I felt I had made my point so I gave thanks for the storm and quit.

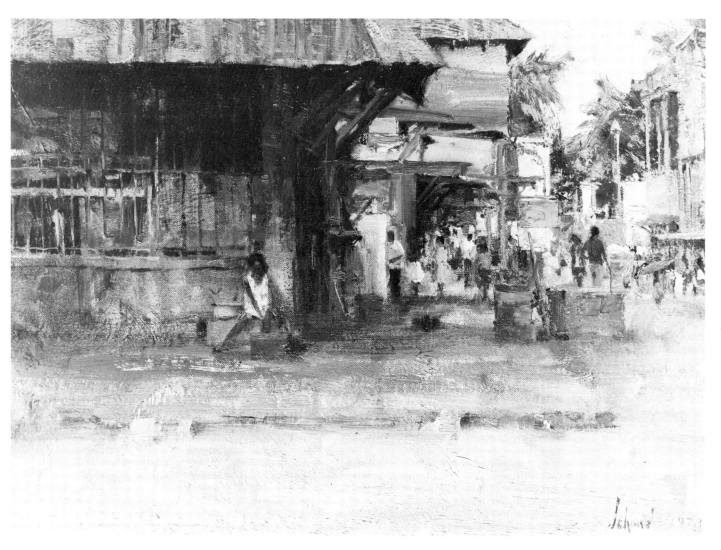

Street in Colon, Panama. Oil on canvas, 12″ x 16″ (305mm x 406mm). A number of years ago on my first visit to the tropics, I was impressed by the contrast between the richness of the colors and the poverty of the people who live there. Neither the color nor the poverty are anything new. I have seen it in all of my travels, yet I am still curious about the combination of deprivation and color. Whatever the reason, it is real and it is there to be painted. The problems of painting on a street corner in a Panamanian city are pretty much the same as painting in Brooklyn. Whenever I paint in public I try to appear like an amateur or a tourist or both. No one pays any attention to either types and until the painting is well along I am usually left to myself. There was only a limited amount of painting time for this sketch, so my intention was to get to direct painting as soon as possible. I wanted a loose color impression rather than a detailed rendering of the street. I began with a transparent wash of cadmium yellow and terra rosa. This, applied in a few swipes with a paint rag, established the overall tonality. From that brief start I painted in all of the darks. The darks and dark halftones came first because they give form to everything. The remaining work continued in more or less the same pattern described in Demonstration 7, but with far less attention to minor detail.

Comogli Street. Oil on canvas, 24″ x 30″ (610mm x 762mm). At the time the sketches and photographs were made for this painting, I was lost. I knew I was in Italy and that I had strayed from the Via Aurelia somewhere between Rapallo and Recco—so this had to be Comogli. It was an Easter Sunday morning, a passing shower had brought out the fragrance of the lemon trees, and the sun was out creating a riot of color. It was too good to miss, yet too much to capture in a tiny sketch, which was all I had time for. So, I used a combination of a brief color sketch and numerous photographs to assemble the larger composition shown here. Again, as in most of the work I do involving photography, I proceeded exactly as I would from life. I find any other approach fatal to the spontaneity and credibility of the work. My general approach here was to begin with a full-color turpentine wash to clearly establish the painting as a whole. This is a fairly large canvas and the pictorial elements, while not unusually difficult, are not simple either. So, it was comfortable to have it all down in transparent color before laying on a lot of thick paint—which I eventually did. The painting was finished in the same manner as ''Caribbean House'' in Demonstration 8.

Cottonwoods. Oil on canvas, 16″ x 30″ (406mm x 762mm). Trees are endlessly fascinating, and I regard them almost as personal friends. It is always hard to view trees dispassionately, as I must, in order to paint them. I once knew someone who failed utterly as a painter, because he always saw things as things and not as shapes of color. The fellow struggled for years but always kept seeing trees and branches instead of color value, shapes and edges. Nature *must* be broken down in this abstract way in order to be interpreted in paint. No artist can duplicate nature, no matter how meticulous and realistic the work appears. There is no point in even trying because that is not what painting is all about anyway. In spite of the fact that, in the finished state of this painting, there is a clear separation between the dominant foreground tree and the leading tree in the middleground, they were treated as color areas inseparable from the shapes that join them. Another way to put this is to explain it in terms of what is known as negative space. To the layman, things that occupy space are separated from one another and surrounded by nothing. In other words, between the first tree and the second, there is only air and everyone knows that air has no shape. The idea of negative space is elementary and self-evident. It holds that what one regards as the edges on the trees, for example, can also be regarded as the edge of a complex shape filled with smaller shapes. Wherever a value or color change occurs, there is a contiguous meeting point or boundary that belongs to both areas of change. That is how I regarded this as well as all other subjects. The houses, land, and sky, etc., which for convenience I say are behind one another, are actually a patchwork of interlocking colors. All this theory remains theory until it is put on canvas. In this case my technique was the same as the impressionistic method in Demonstration 2. This painting, however, was carried a bit farther toward realism than the demonstration painting.

Bibliography

Carlson, John F. *Carlson's Guide to Landscape Painting*, 9th printing. New York: Sterling Publishing Co., Inc., 1971.

Cecchi, Dario. *Antonio Mancini*. Torino, Italy: Unione Tipografico, Editrice Torinese, 1966.

Doerner, Max. *The Materials of the Artist: And Their Use in Painting*. New York: Harcourt Brace Jovanovitch, 1949.

Henri, Robert. *The Art Spirit*. New York: Lippincott, 1930.

Koningsberger, Hans. *The World of Vermeer*. New York: Time, Inc., 1967.

Logu, Giuseppi de. *Pittura Italiana Dell'Ottocento*. Bergamo, Italy: Instituto Italiana D'Arte Grafiche, 1962.

Mayer, Ralph. *The Artist's Handbook of Materials and Techniques*, 3rd edition. New York: Viking Press, 1970.

Neumann, Jaromir. *Modern Czech Painting and the Classical Tradition*. Prague: Artia, 1955.

Novotny, Fritz and Johannes Dobai. *Gustav Klimt*. New York: Fredrick A. Prager Publishers, 1968.

Pirenne, M.H. *Optics, Painting and Photography*. New York: Cambridge University Press, 1970.

Rubissow, Helen. *The Art of Russia*. New York: Philosophical Library, 1946.

Schmid, Richard. *Richard Schmid Paints the Figure*. New York: Watson-Guptill Publications, 1973.

Index

Edited by Joan Fisher
Designed by Bob Fillie
Set in 11 point Medallion by Publishers Graphics, Inc.